SIR LAWRENCE
ALMA-TADEMA

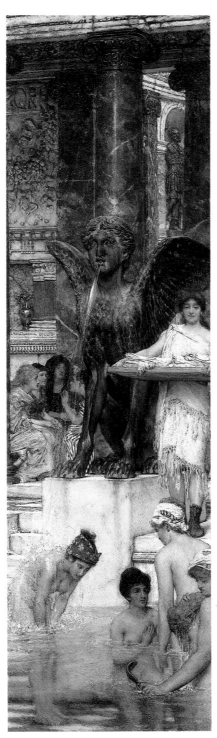

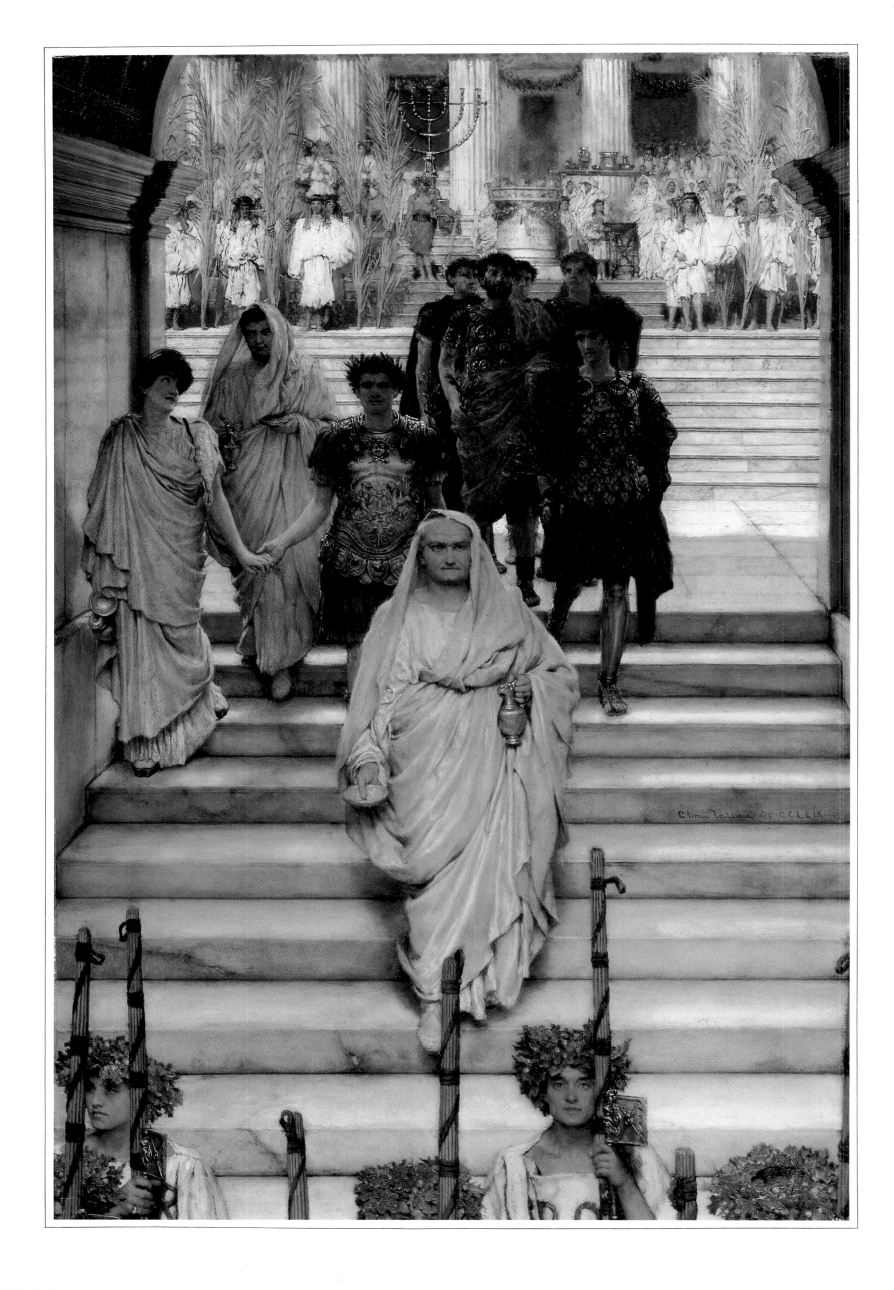

SIR LAWRENCE
ALMA-TADEMA

RUSSELL ASH

PAVILION
MICHAEL JOSEPH

SIR LAWRENCE ALMA-TADEMA
— 1839–1912 —

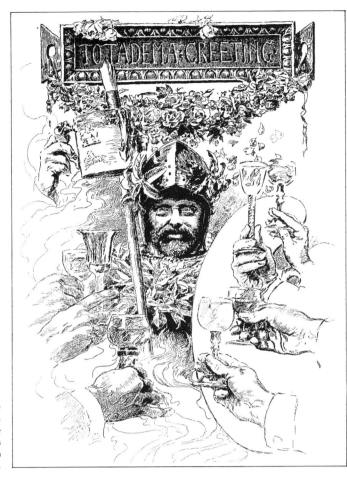

Fellow artists pay tribute to Alma-Tadema on the occasion of his knighthood in 1899.

Who knows him well he best can tell
That a stouter friend hath no man
Than this lusty knight, who for our delight
Hath painted Greek and Roman.
Then here let every citizen,
Who holds a brush or wields a pen,
Drink deep as his Zuyder Zee
To Alma-Tad –
Of the Royal Acad –
Of the Royal Academee.

This, the refrain of a song composed especially for Sir Lawrence Alma-Tadema, was performed at the banquet held to celebrate his knighthood, awarded to him on Queen Victoria's eightieth birthday in 1899. The timing was coincidental, but perhaps not inappropriate, for Alma-Tadema, born the year before Victoria came to the throne, and Victorian England had grown old and prospered together. Alma-Tadema, more than any other painter of the High Victorian period, had intuitively sensed the spirit of the age and, clever businessman that he was, had achieved unrivalled success by producing the most popular, the most reproduced and the most expensive pictures of his day. Yet already, as the end of the century neared and Victoriana was becoming despised and sloughed off, he was an artist out of his time. Within twenty years one would have been hard-pressed to find a buyer for an Alma-Tadema painting, and if one did change hands, a work that might once have commanded £10,000 could have been picked up for £20. Along with the decline in interest in his work, his fame was steadily eclipsed: his knighthood, his rôle as a leading Royal Academician, his

friendship with Society figures from the Prince of Wales to the young Winston Churchill, all were forgotten. Barely forty years after his death, the author of an article on him felt compelled to explain that, despite his strange name, Alma-Tadema was not a woman.

Since the 1960s, however, alongside a general resurgence of interest in the best of Victorian art (as well as some of the worst), Alma-Tadema's star has been shining again. In 1973 the art world gasped when *The Finding of Moses* made £30,000 at auction; in 1980 *Caracalla and Geta* fetched £145,000, while more recently paintings are known to have been sold privately for more than £500,000. Now, nearly eighty years after his death, no one would be surprised if a first-rate picture fetched £1m or more.

Alma-Tadema's story is not a rags to riches tale. His was not the angst-filled life of the penniless artist starving in a garret, never selling a painting until after his death; he was not rejected by the establishment – on the contrary, he was the establishment's favourite artist; nor, in Oscar Wilde's phrase, was his 'a life crowded with incident'. He was twice happily married and, as far as anyone knows, he never engaged in torrid affairs with his models. But lacking high drama, the life of this comfortable, successful and above all internationally popular painter reveals more about Victorian life, Victorian taste and 'Victorian values' than that of almost any other artist of the era.

Alma-Tadema was Dutch, and his name was originally Lourens Tadema; Alma was his middle name. He was born on 8 January 1836 in Dronryp, Friesland, the son of the local notary, Pieter Tadema, and his second wife, Hinke Brouwer. The family moved two years later to the provincial capital, Leeuwarden, where, in 1840, Pieter Tadema died. As he grew up, Lourens showed some artistic ability and the beginnings of his methodical nature: in

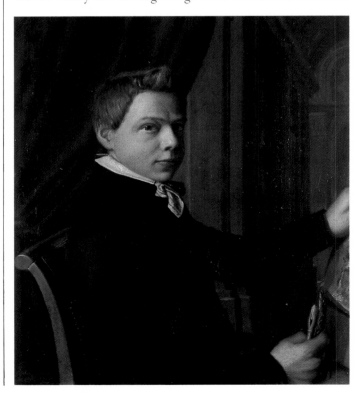

Lourens Tadema's proficient self-portrait, painted at the age of 16.

1851, in his own catalogue, he assigned to a portrait of his sister the Roman numeral 'I' preceded by 'Op.' [Opus] – a practice that he continued throughout his life (though he included the numbers on his paintings alongside his signature only from 1872), ending with 'Op. CCCCVIII' at the time of his death.

In 1852 he enrolled as a student at the Antwerp Academy, where he worked briefly under Gustav Wappers and then his successor, Nicaise de Keyser. Both were exponents of the Romantic movement, de Keyser in particular encouraging his pupils to paint genre subjects on nationalistic themes. Tadema later became an assistant to the historical painter Baron Hendryk Leys and lived in the household of an archaeologist, Louis de Taye (under whose roof were also the noted Hague School painters, Jacob and Willem Maris). From Leys and de Taye Tadema began to develop his interest in and knowledge of archaeology and history, which was further fostered by contact with the German Egyptologist, Georg Ebers (later one of Tadema's biographers), and assisted Leys in painting historical murals in the Antwerp Town Hall. His cousin Willem Mesdag, himself a painter of note, became one of his pupils and one of the first collectors of Tadema's work.

The themes for his early paintings derived from the history of the Merovingians, rulers of Gaul from the sixth to the eighth century. This little-known and in many respects bleak period preoccupied him until 1862 when he visited London

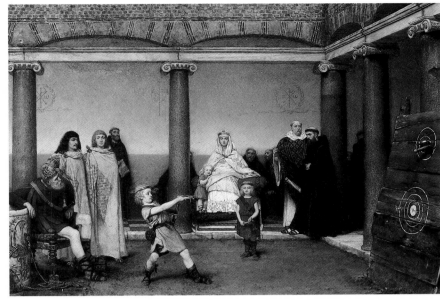

Tadema's study of Merovingian history resulted in subjects such as *The Education of the Children of Clovis* (1868).

for the first time, during the International Exhibition. He was deeply impressed by the Elgin Marbles and especially by the Egyptian artefacts he saw in the British Museum and turned increasingly to Egyptian themes in his work (an area he had already explored in his *The Sad Father* of 1859). In 1863 he married a Frenchwoman, Marie Pauline Gressin de Boisgirard, and spent his honeymoon in Italy. There he intended studying the architecture of early Christian churches; instead he became so fascinated by the Roman remains, marble and the newly-excavated ruins of Pompeii that he immediately added ancient Roman subjects to his repertoire. Within a few years such works, 'reanimating the life of the old Romans', as one critic described them, took prominence. Soon afterwards, Tadema and his wife, Pauline, moved to Paris, where he met 'Prince' Ernest Gambart, an eminent art dealer with pan-European connections, entering into a long-term contract with him and soon transferring his studio to Brussels.

In the Peristyle (1866), a portrait of Tadema's first wife in a flowery Pompeian courtyard.

Tadema inspecting the newly-excavated ruins of Pompeii.

The 1860s were marked by a double tragedy: his only son died of smallpox in 1865 and his wife died in 1869, leaving him to support their two daughters, Anna and Laurence. By the end of the decade, however, Tadema's work was being exhibited in London and was attracting a growing following. In 1869 two of his paintings, *A Roman Art Lover* and *Phyrric Dance*, were shown at the Royal Academy. The second of these later prompted the critic John Ruskin to remark that

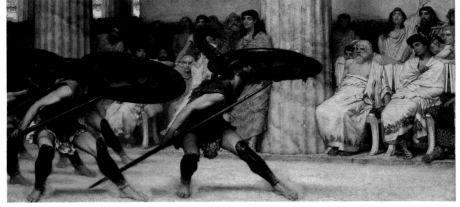

The Phyrric Dance (1869), one of Tadema's first paintings to be exhibited in London.

'the general effect was exactly like a microscopic view of a small detachment of black-beetles, in search of a dead rat'. Ruskin's was, though, one of the few dissenting voices: so well were Tadema's paintings received that, visiting England in this year (to consult a doctor, Sir Henry Thompson), and with the threat of the Prussian invasion of France, he made the decision to move his base to London in 1870 (as did such artists as Monet and Pissarro). The following year he married his seventeen-year-old pupil, Laura Epps, the daughter of a doctor and member of a family celebrated in the Victorian period for the manufacture of cocoa.

In 1873, Tadema became a naturalized British citizen. A verse accompanying a caricature went:

> Great are your gifts; we in England have had 'em a
> Good many years, and we value them much, man.
> Lucky the day when you cried, Alma Tadema,
> Briton I'll turn; if I don't, I'm a Dutchman!

As well as establishing that Alma-Tadema had 'arrived' sufficiently to be the subject of a magazine cartoon, it indicates the correct pronunciation of his name 'Tad-em-a', to rhyme with 'had 'em a', and not 'Tad-ee-ma'. From the time of his settling in London, he also consciously joined his

middle name, Alma, to his surname. As well as making it more memorable, it had the effect of elevating him to an early position in alphabetical catalogues. He never hyphenated it himself, but almost everyone else did and this has become the convention.

Soon after his remarriage, the Alma-Tademas moved from a rented home in Camden Square to Townshend House, a villa at the north gate of Regent's Park. Elegantly and eclectically decorated in cosmopolitan style, it rapidly became a popular venue for gatherings of fellow artists.

Back in 1866, when Alma-Tadema was visiting Gambart in London, his host's home had been shattered by a gas explosion from which he and Pauline were lucky to escape with their lives. In 1874 he was again the victim of a bizarre explosion. At dawn on 2 October on the Regent's Canal a steam tug towing five barges carrying petroleum and five tons of gunpowder exploded with such force that the bridge was entirely destroyed and houses over about a square mile were gutted. Thousands of windows were shattered and shock waves were felt thirty miles away. The most severely damaged house was the Alma-Tademas', but luckily he and his wife were in Scotland at the time and miraculously no one apart from the crew of the tug was killed. While Townshend House was being repaired, he took his family to Italy for the winter.

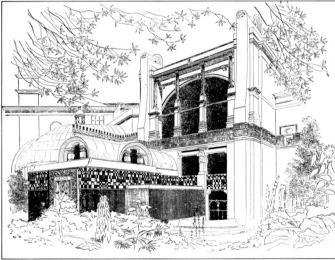

The studio entrance to Alma-Tadema's house in St John's Wood, drawn while under construction.

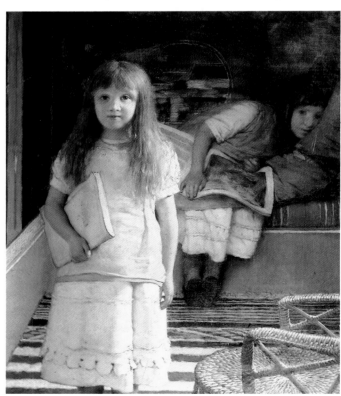

This is Our Corner (1873), Alma-Tadema's daughters, Laurence and Anna.

Steadily, Alma-Tadema was achieving fame and wealth: he became an Associate of the Royal Academy in 1876 and a full Royal Academician in 1879. In 1882 the Grosvenor Gallery staged an exhibition of 287 of his paintings. Now one of the most famous painters in Britain, he felt sufficiently confident to develop plans for a yet more spectacular home. The house he found was in Grove End Road, St John's Wood – an area once noted for the number of houses occupied by high-class courtesans. This was the former home of the French artist Jean-Jacques Tissot, who in 1882 had abandoned it after the death of his mistress, Kathleen Newton. It was modest, but had a number of classical features that appealed to Alma-Tadema, such as the colonnade beside a garden pond that featured in several of Tissot's works. Alma-Tadema

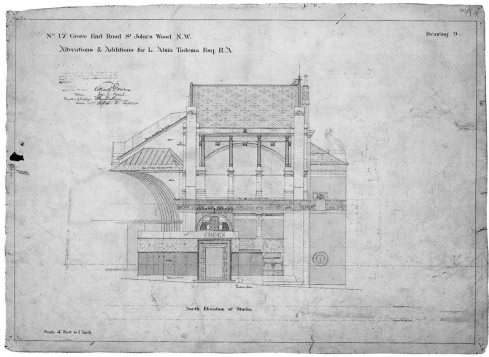

greatly expanded the house, making of it an extraordinary palace, designing every detail himself, from the artist's palette weather-vane and the doorway, modelled on one from Pompeii, with 'Salve' – 'Welcome' – above the door, down to the rainspouts in the shape of lions' heads. The hall was lined with panels painted by fellow artists, and the vast galleried marble-floored studio was surmounted by a polished aluminium dome. The brightness of the light it reflected noticeably affected Alma-Tadema's painting from this time onwards.

Both Alma-Tadema's London houses were famous for his well-attended 'At Homes' and elaborate parties. He loved dressing up for fancy-dress balls – sometimes, appropriately, as a Roman emperor. Music was always on the menu, and his many distinguished visitors included Tchaikovsky and Enrico Caruso. Those who performed at his magnificently decorated piano were then asked to sign a vellum panel inside the lid. (Sadly, it was destroyed by bombing during the Second World War, but in 1980 a piano designed by Alma-Tadema for Henry Marquand of New York made £177,273 at auction, making it to that date not only the most expensive musical instrument ever sold, but also the most costly example of nineteenth-century applied art.)

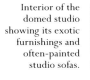

Interior of the domed studio showing its exotic furnishings and often-painted studio sofas.

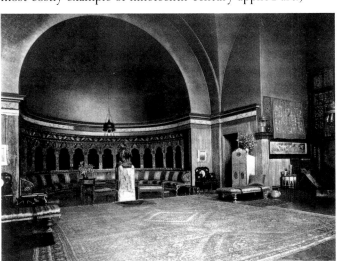

Dominating the 'At Homes' was Alma-Tadema the host. His genial personality and sense of humour were legendary – notorious, some said. He was an avid collector of clockwork toys and could be found sitting, childlike, on the floor roaring with laughter over a tin monkey beating a drum. He embarrassed Sir Georg Henschel (the conductor of the Boston Symphony Orchestra) by insisting whenever they met that he sing the music hall song, 'Daddy Wouldn't Buy Me a Bow-Wow'. He had a passion for dreadful puns and jokes which he delivered in the thick Dutch accent that he never completely lost. On one occasion he met Angela Thirkell (Burne-Jones's granddaughter and a well-known novelist). He was gabbling volubly, and she could not understand what he was saying but assumed it must be one of his appalling stories and laughed uproariously, only to be asked by the astonished Alma-Tadema, 'What for you laugh when I tell you that

Alfred Parsons' mother is dead?' Some found him overpowering and it cannot be denied he was a flamboyant and self-obsessed extrovert. The initials 'LAT' (which, to be fair, were those of his wife as well as himself) were interwoven into the floors and walls of his houses, and even engraved on the screws of his famous piano. He was undoubtedly the sort of man who would today have a custom-built Rolls-Royce with the 'prestige' car registration plate, 'LAT 1'.

Though he was without honour in his own country, where artists such as those of the Hague School took the fancy of patrons while his work was unappreciated, he was hugely popular almost everywhere else, from the United States to Australia. He received awards and honorary titles by the dozen from European and American institutions, with the final accolades in Britain of his knighthood in 1899 and the rarely-awarded Order of Merit in 1905. His clients included members of the British Royal Family and Russian Imperial Family, and his pictures found their way into important private collections as far afield as India and New Zealand. He became a noted Society portraitist – some sixty of his paintings are routine commissioned portraits of subjects ranging from the British Prime Minister Arthur Balfour to the Polish pianist (and later Polish Prime Minister) Ignacy Paderewski.

Lady Laura Alma-Tadema died in 1909 and was buried at Kensal Green cemetery. Alongside her grave, he reserved a plot for himself. Following her death, Alma-Tadema's *joie de vivre* was noticeably declining, but he produced several remarkable pictures before his own death on 25 June 1912 in the German spa of Wiesbaden. He was not buried with his wife: so high had he risen in the artistic pantheon that nothing less than St Paul's Cathedral was thought appropriate. Soon afterwards, his house and contents were sold. The house was later divided into apartments and few architectural details survive. In 1975 it acquired a Greater London Council 'blue plaque', installed to commemorate the residences of celebrated people. Alma-Tadema's is unusual: as the house is almost invisible from the road, the plaque is attached to the garden wall. His daughters Laurence and Anna lived on until 1940 and 1943 respectively, dying as elderly spinsters.

The architect's plan for the imposing conversion of Alma-Tadema's 'palace'.

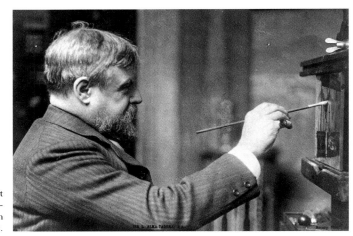

The establishment artist: Alma-Tadema at work in the 1890s.

During his sixty productive years, Alma-Tadema had produced over four hundred paintings. In this period, his technical virtuosity, as even Ruskin acknowledged, increased year by year. His work also underwent several dramatic changes of style and content. Firstly the historical location moved successively through obscure Merovingian subjects and Egyptian themes to Pompeian and Roman settings. In content he developed progressively away from defined historical scenes into cosy, often sentimental domestic settings. Most striking of all was his move from the dark into the light: gradually his subjects, originally placed in gloomy interiors, passed through doorways and on to terraces, finally emerging into dazzlingly brilliant light reflected off shimmering white marble in broad, open spaces – often on coastal promontories flooded with sunlight. The extraordinary luminosity of his paintings is all the more remarkable when one notes that he never used glazes or varnish. His technique depended on painting dark pigments on to white canvas, rather than the then conventional technique of adding highlights to a dark background. His palette was not unlike that of his contemporaries, the Impressionists, but in few other respects did he follow their technique. He was also clearly a consummate master of the chemistry of his paint, since works he painted over a century ago still appear fresh and bright, rarely showing any signs of deterioration. Most of his paintings are oils, but he was equally competent in watercolour and pencil; diverse examples exist, from crude sketches to incredibly detailed finished drawings.

Though he was able to convey almost any texture, from fur to feathers, it was his painting of marble that singles Alma-Tadema out from his rivals. His original inspiration came, it is said, from an 1858 visit to a club in Ghent in which there was a marble-lined smoking-room. Recalling an early criticism of his teacher, Leys, who remarked that one of his first attempts at depicting marble 'looked like cheese', he studied it at every opportunity, visiting the quarries at Carrara, and made himself the world's leading exponent of marble painting: 'Marbellous!', quipped *Punch*. In an address to the Royal Institute of British Architects, he informed his audience, ' . . . marble is beautiful stuff of deal with.' Even those artists who had little sympathy with his work acknowledged his skill: 'No man has ever lived who has interpreted with Alma-Tadema's power the incidence of sunlight on metal and marble,' wrote the Pre-Raphaelite painter Sir Edward Burne-Jones.

Having achieved this pre-eminence, he featured marble at every opportunity. The marble bench, or *exedra*, on which lovers sit in bright sunshine, lost in their reveries, was a characteristic theme to which he often returned. In these and in many other works he frequently 'recycled' successful elements, perhaps taking an incidental detail from one and working it up into a full-scale painting. Alternatively, he might produce several versions of a work, ringing the changes by producing one in watercolour and one in oils, altering the size, or modifying certain features. Occasionally he could be self-mocking about this technique, as when, following the success of *An Audience at Agrippa's*, he painted *After the Audience*, in which we see the backs of the same figures as they exit. Some archaeological props also recur again and again – a studio sofa (now in the Victoria & Albert Museum), for example, appears in many pictures.

Alma-Tadema was the foremost depicter of the daily life of the ancient world; unlike such artists as Lord Leighton or Poynter, he did not attempt to portray Greek legends, nor, as his work progressed, did he pay much attention to named historical personages or events – or almost anything that involved action. His were set pieces, scenes in which a moment in time was frozen almost photographically, and the moments themselves were ones in which not much is going on. Bacchantes are seen calling people to participate in revels that we never witness, or lying exhausted after they are over; lovers sit idly on sofas gazing dreamily into the distance; sometimes his subjects are actually asleep.

Alma-Tadema was often criticized for painting decorative objects, marble and skies with greater conviction than that

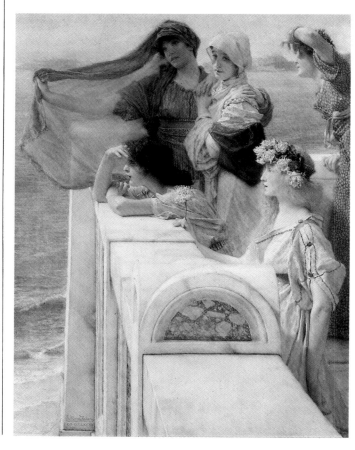

The perfect blend of women, marble and the Mediterranean in *At Aphrodite's Cradle* (1908).

which he applied to the flesh of the human beings who inhabited his pictures. In Ruskin's view, Tadema's technical perfection was in inverse ratio to the importance of the subject he was portraying. Others saw his figures, with their lack of movement or emotion, as no more than soulless dummies, mere compositional accessories. Alma-Tadema would have been the first to admit that there was little spiritual dimension to his works; no social or moral lessons were being conveyed, as in the paintings of the Pre-Raphaelites, his view being that art should elevate, not teach. Even the historical and psychological backgrounds to many of his works were submerged in the

spectacle – *The Roses of Heliogabalus* actually shows the psychopathic Roman emperor suffocating his guests under a shower of rose petals, but it was the quality of Alma-Tadema's skill at depicting roses (brought to his studio weekly for the purpose from the South of France), not the cruelty of the maniac ruler, that excited the critics. While most genre paintings in contemporary costume or allegorical historical subjects tended to dwell on moral questions, Alma-Tadema's art was devoid of 'messages' – but then it was also free of the constraints of 'high art': his, if art it was, was art on an anecdotal level. He had no aspiration beyond that of being a painter of beautiful things – of flowers and decorative objects in picturesque settings, peopled by women and men in attractive costumes.

An Apodyterium, voted 'Picture of the Year' in 1886.

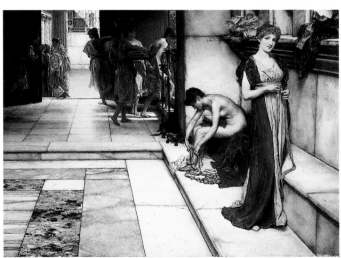

But if his art lacked substance, no one could complain that he short-changed his public on the technical skill and archaeological exactitude with which he depicted the ancient world – to the extent that several generations of school history books featured his paintings as the most accurate representations of daily life in Rome. Widely read, he was the possessor of a substantial library of reference books as well as 167 massive albums of drawings, prints and photographs (donated to the Victoria & Albert Museum, but now held by the Birmingham University Library). To these he would turn for precise visual information. In addition, he had a phenomenal memory for details gleaned on his travels in Italy, Egypt and elsewhere. Almost every object, every vase, statue or bas-relief, derives from some museum exhibit.

Only very rarely is there an anachronism – as when he placed sunflowers in a Roman picture without appreciating that they were indigenous to the Americas.

His scholarship could be turned into paintings only through enormous effort. Take, for example, *Caracalla and Geta*: in a segment comprising one-seventh of the Coliseum, which held 35,000 spectators, he calculated that there would be 5,000 people, half of whom, he estimated, were concealed behind pillars and garlands of flowers. Undaunted, he proceeded to paint 2,500 figures. This is, for Alma-Tadema, a relatively large painting, measuring 4 ft by 5 ft, but many seeing his pictures for the first time are astonished to discover how tiny many of them are. He was proud of his talent as a miniaturist, and often gave a visitors a magnifying-glass with which to inspect some miniscule detail.

Alma-Tadema's perspective is often unconventional, a work like *A Coign of Vantage* presenting strikingly vertiginous angles. In his paintings the viewer is often guided through a doorway. The subject might be framed by bold horizontal or diagonal elements, or figures truncated at the edges of the frame, after the fashion of a Japanese print. Nothing is accidental; every single element is worked out to fit into the whole. Never completely satisfied with his pictures, he repeatedly reworked them – sometimes after they had been sold. Some of his early works were hacked up into sections and made into several smaller paintings; one rejected painting even ended up as a tablecloth. His meticulous supervision of the engravers who reproduced his work was often exasperating. He was a hard-working perfectionist who could not tolerate anything less in his associates.

With varying degrees of success, Alma-Tadema dabbled in many creative endeavours, which he described as 'the sister arts'. He executed a number of book illustrations and stage sets, also designing theatrical costumes, such as that worn by Ellen Terry as Imogen in *Cymbeline*, which became an overnight fashion, as did Liberty's Roman dresses 'à la Tadema'. His chief contribution outside painting, however, was in the field of architecture. In 1906 he won the Gold Medal from the Royal Institute of British Architects for his promotion of architecture through his painting, the only artist ever to receive the award. Alma-Tadema's architectural obsessions ensured that even if it never existed *in toto*, every building he depicted could have been built – his paintings were almost blueprints for fantasy Roman buildings.

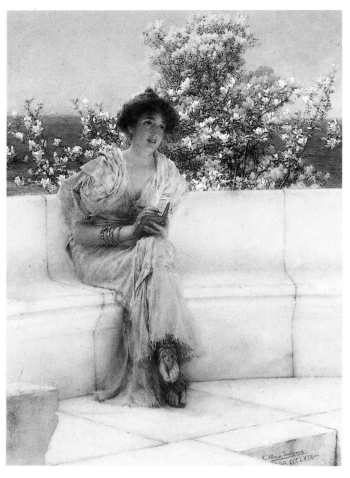

'The Year's at the Spring, All's Right with the World' (1902) – late Victorian sentimentality in a vaguely antique setting.

Tadema specialized in painting depictions of esoteric historical events only until he found the niche in which he stayed for the rest of his prolific life. This was the portrayal of the luxury, tranquillity and mores of the upper-middle-class circles in which he himself mixed – their love of art treasures, dining and fashionable parties, their courtship rituals, sentimentality and even their repressed sexuality. The fact that his audience expressed its desire to be represented as elegant 'Victorians in togas', as one art critic has called them, is less easy to comprehend today. What was the secret of the appeal of Alma-Tadema's paintings of his contemporaries in antique fancy dress?

In his incredibly detailed reconstructions of the ancient world, Alma-Tadema provided his public with an uncomplicated, acceptable, and occasionally risqué image of rich patricians, art-lovers and wooing couples; and in particular he was the first to show that the Roman middle class was not unlike the Victorian middle class – 'I have always endeavoured to express in my pictures that the old Romans were human flesh and blood like ourselves, moved by the same passions and emotions,' he explained in an interview in the year of his knighthood. Alma-Tadema was the first artist to use the wealth of archaeological evidence that was being uncovered and published to reconstruct the daily life of ancient Rome in a form that was infinitely more accessible than the loftier works of those artists who attempted to portray significant historical events or obscure myths and legends.

In the Victorian self-image there were obvious parallels between the attainments, the values and the social stratification of the Roman Empire and those of the 'golden age' of the British Empire. Alma-Tadema's public may or may not have consciously appreciated this mirroring of their own society in his paintings, but to modern eyes his reflections of Victorian bourgeois values are obvious enough: property ownership, art connoisseurship, infinite leisure time – especially exemplified in the idleness of the wives of successful men – servants catering to every whim, sentimentality relating to courtship, children who were seen but not heard.

It would not be an exaggeration to state that Alma-Tadema was the most successful and popular of all Victorian painters. All his works, highly priced though they were, found eager buyers; engraved reproductions of his pictures sold in their thousands, while Frederick Stephens' booklet describing one of his paintings, *A Dedication to Bacchus*, was reputed to have sold 40,000 copies. Alma-Tadema was able to support his lavish lifestyle – his palace of a house, extravagant entertaining and extensive travels – purely from the income from the sale of his pictures and copyrights for reproduction. He was one of the most highly-paid artists of his day: *A Reading from Homer*, sold to an American buyer for $30,000 in 1903, was the most expensive painting of the year. For the copyright of *The Baths of Caracalla*, widely reproduced as a print, he received a staggering £10,000. A century ago a less complex but characteristic work might fetch over £2,000, while a portrait commission would command £600 to £800 – figures that should be multiplied by at least thirty to compare them with modern values. It should also be noted that income tax in his peak years was threepence in the pound.

The simple explanation of this achievement is that for over sixty years, like any shrewd entrepreneur, he cleverly calculated precisely what his audience wanted, and gave it to them. Alma-

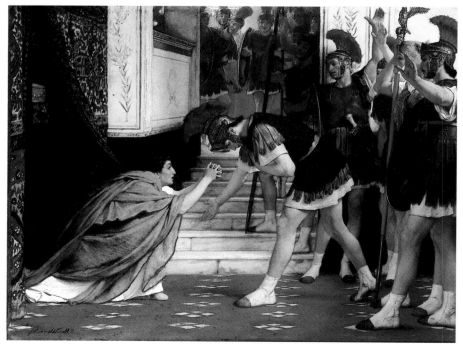

The melodrama of such works as *Proclaiming Claudius Emperor* (1867) was later supplanted by simple scenes of daily life.

To a materialistic public he provided true value for money – finely detailed paintings crammed with figures, decorative archaeological paraphernalia, and multitudes of flowers, as cluttered as a Victorian drawing-room. He gave glimpses into the past – endlessly fascinating conversation pieces to tempt the jaded palates of a society that constantly sought new pleasures. Recognizing the appeal of Mediterranean colour and sunlight to northern Europeans and Americans, in his most popular works he focused on the Bay of Naples. He also offered an underlying escapism: never is there anything unpleasant or dirty, rarely a tinge of sadness; everything is elevated to a refined and pleasurable plane. Above all, he was the right man at the right time: the Victorian public was complacent (Alma-Tadema's painting, *'The Year's at the Spring, All's Right with the World'*, could have served as a motto for the entire era) and self-assured with its own place in world history. It was also obsessed with the past, with revivals, discoveries and novelties, and Alma-Tadema's vision struck a perfect balance between erudition and entertainment.

Alma-Tadema realized that the mercantile class that provided most of his patrons included many *nouveaux riches* who lacked the benefit of a classical education. Like the popular singer of today who offers a medley of popular arias without the complexity or tedium of the whole opera, he preferred respectably historical paintings with simple and straightforward anecdotal backgrounds, eschewing convoluted legends and characters with unpronounceable names. This attitude extended even to the simplicity of the titles of his paintings: he soon moved away from history book captions such as *Queen Fredegonda at the Deathbed of Bishop Praetextatus* to short phrases such as *Midday Slumbers* or *The Voice of Spring*, or such memorable quotations as *'Her Eyes Are With Her Thoughts, and They Are Far Away'*.

An undeniable element in the appeal of Alma-Tadema's works (especially since those who bought them were usually men) was that they often contained tasteful erotica. Alma-Tadema's subjects may be 'Victorians in togas', but as often as not they are caught in the act of slipping out of their togas or cavorting naked in Roman baths. How deliberate Alma-Tadema's choice of sexually arousing subjects might have been is not hard to assess: time and time again he returned to themes with coyly erotic potential – or, in the case of a work like *In the Tepidarium*, not so coy. We are repeatedly offered an almost voyeuristic glimpse inside baths and changing rooms, while the Roman world is populated by bacchantes exhausted after a wild orgy, nude sculptors' models and languid women barely covered by loosely draped towels or diaphanous, figure-clinging gowns. There are even suggestions of lesbianism as we meet Sappho and discover women

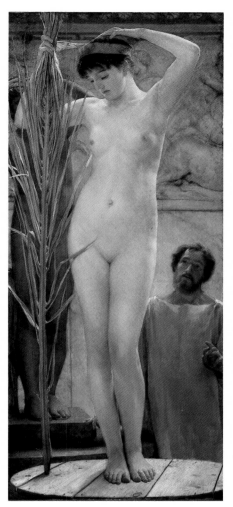

hugging and lounging intimately together in boudoirs.

A letter from the Bishop of Carlisle to the portrait painter George Richmond encapsulated what the more puritanical among his audience must have felt:

My mind has been considerably exercised this season by the exhibition of Alma-Tadema's nude Venus [*A Sculptor's Model*] . . . [there might] be artistic reasons which justify such exposure of the female form. . . . In the case of the nude of an Old Master, much allowance can be made, but for a living artist to exhibit a life-size life-like almost photographic representation of a beautiful naked woman strikes my inartistic mind as somewhat if not very mischievous.

It was rumoured that Alma-Tadema had been commissioned by Edward VII to produce a series of more avowedly pornographic works; some even said he had painted murals discreetly hidden behind curtains in Windsor Castle. The verdict on this must remain 'unproven'. As far as the public at large (*pace* the Bishop of Carlisle) was concerned, Alma-Tadema never overstepped the mark: to ensure that his publicly shown paintings were respectable and hence acceptable, he placed his models in strictly classical settings (after all, every school-boy knew that the Romans spent hours in Roman baths, and no one bathes with their clothes on); to the scene he added a wealth of meticulous archaeological detail. Without question, these were serious historical paintings, successors of a long tradition of such works in which the presence of a nude, if justified by the context, was perfectly within the bounds of decency.

Several writers have seen in Alma-Tadema's more complex compositions an anticipation of the grandeur of the wide-screen Hollywood epic, and films such as D. W. Griffith's *Intolerance* (1916), *Ben Hur* (1926), and Cecil B. De Mille's *Cleopatra* (1934) and *The Ten Commandments* (1956) may well owe something to Alma-Tadema's vision of Rome in all its glory. *Spring* and other Roman crowd scene paintings were already in American collections and were well known through reproductions. (Many of his works were bought by American connoisseurs, and today almost half his *oeuvre* is in public and private collections in the United States.) Jessie Lasky Jr, co-writer on De Mille's *The Ten Commandments*, has described how the producer would customarily spread out reproductions of Alma-Tadema paintings to indicate to his set-builders the design he wanted to achieve, so Alma-Tadema's appellation as 'The Painter Who Inspired Hollywood' may not be too far-fetched.

A Sculptor's Model (1877), the painting that shocked the Bishop of Carlisle.

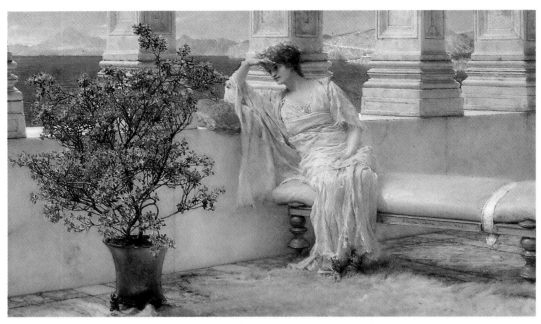

'*Her Eyes are With Her Thoughts, and They Are Far Away*' (1897),
a wistfully decorative subject typical of the 1890s.

The 1913 Royal Academy memorial exhibition devoted to Alma-Tadema attracted only 17,000 visitors (Landseer's, a generation earlier and at the pinnacle of his fame, drew over 100,000). Those who had known him were polite enough, but the tide of opinion was already turning, one critic acidly commenting that his pictures were 'about worthy enough to adorn bonbon boxes'. It was the beginning of an anti-Alma-Tadema phase that was to last fifty years. Its chief exponents were Augustus John and his contemporaries in the Bloomsbury Group, to whom Alma-Tadema and his ilk were anathema. The backlash is understandable: Alma-Tadema was the most representative Academy painter of the nineteenth century, the personification of High Victorian art, and when this was rejected out of hand, Alma-Tadema, once the highest of them all, had the furthest to fall.

He was so much a product of his age that, when Victoriana came to be despised, Alma-Tadema's reputation steadily sank. It eventually reached such an all-time low that art galleries were literally throwing his paintings out. Some were sold for insultingly low prices: in 1954 Exeter City Art Gallery got rid of '*The Year's at the Spring, All's Right with the World*' for 130 guineas, while *In a Rose Garden* left the Lady Lever Art Gallery in 1958 for £241 10s. In 1960 *The Roses of Heliogabalus*, commissioned in 1888 for £4,000, and *The Finding of Moses* (£5,250 in 1904) failed to find buyers willing to pay more than £105 and £252 respectively.

The turning-point came about 1962, when the Robert Isaacson Gallery in New York audaciously celebrated the fiftieth anniversary of Alma-Tadema's death by exhibiting twenty-six of his paintings. Prices began to rise along with the general revival of interest in Victorian art – but in Alma-Tadema's case the escalation was curiously spurred by the enthusiasm of Allen Funt, the American film producer and creator of the popular television programme, 'Candid Camera'. Funt perversely built up the world's largest collection of Alma-Tadema paintings, originally to furnish a room decorated in Roman style, but with increasing momentum after he discovered that Ruskin had declared Alma-Tadema to have been the worst painter of the nineteenth century. Funt sprang to his defence, later commenting, 'Soon I found myself with a houseful of Alma-Tadema paintings and a warm feeling of sympathy for

this painter who received rather critical treatment.' Funt came to appreciate the collection of thirty-five paintings he assembled over the next eight years. In 1972, however, Mr Funt's accountant, when discovered to have been embezzling his funds, committed suicide, leaving him, as he described his situation, with 'everything a rich man has – except cash'. The Alma-Tademas had to go, but their potential at auction was encouraging, *Spring* having been sold in that year for $55,000. After a swan-song exhibition at the Metropolitan Museum of Art in New York, they crossed the Atlantic to be sold at Sotheby's, where they realized a total of £234,000. Interestingly, the sale included both *The Roses of Heliogabalus* and the *The Finding of Moses*: just thirteen years after they had been rejected at £105 and £252, they fetched £28,000 and £30,000 respectively – the latter a new record for an Alma-Tadema painting.

In the same year the present author's short biography of Alma-Tadema was published – the first book on him for over sixty years. This was followed by exhibitions organized at the Princessehof Museum in Leeuwarden in 1974 and at Sheffield City Art Gallery in 1976. In 1978 Vern Swanson's *Alma-Tadema: The Painter of the Victorian Vision of the Ancient World* was published in Britain and the United States as well as in French and Dutch. Mr Swanson has been working for many years on the *catalogue raisonné* of Alma-Tadema's paintings, and has been responsible for the acquisition and promotion of his work, particularly at Brigham Young University Art Museum in Provo, Utah.

Rather than being pilloried for being a man of his time, Alma-Tadema is today acknowledged as representing in his works the epitome of High Victorian taste. Once criticised for the lack of 'soul' in his work, or as an arch exponent of kitsch, he is now again admired as one of the most incredibly skilled technicians of all time, in whose pictures no intricate detail, however minute, is left to the imagination. His richly coloured, sumptuous and stunningly lit scenes have a freshness and impact that even now, over a century after some of them were painted, still have the power to amaze.

The Plates

——— PLATE 1 ———

A SCULPTURE GALLERY

Opus XLIX, 1867
Oil on panel, 24½ × 18½ in/62.2 × 47 cm
Musée des Beaux Arts de Montréal

The studios of Roman painters and sculptors and the galleries
in which their work was displayed to art connoisseurs
feature strongly in Alma-Tadema's early paintings. Here, in a
picture the full title of which is *A Sculpture Gallery
in Rome at the time of Augustus*, we see a group viewing a bronze
statue of the Greek dramatist, Sophocles. Like many of
his paintings in which sculpture appears, it was based on an
original work of art, in this instance a marble statue
found at Terracina in 1839 and now in the Vatican Museum.
In the background is the group depicting Laocoön and
his sons being killed by snakes, which is also in the Vatican.
On the right in profile is the seated figure of Agrippina
from the Capitoline Museum. Between the garlands,
suspended from the decorative ceiling, is an *oscillum*, or
decorative roundel. As was Alma-Tadema's usual custom, he
signed the painting on a suitable expanse of marble, but
he had not yet begun his practice of adding Opus numbers
alongside his signature.

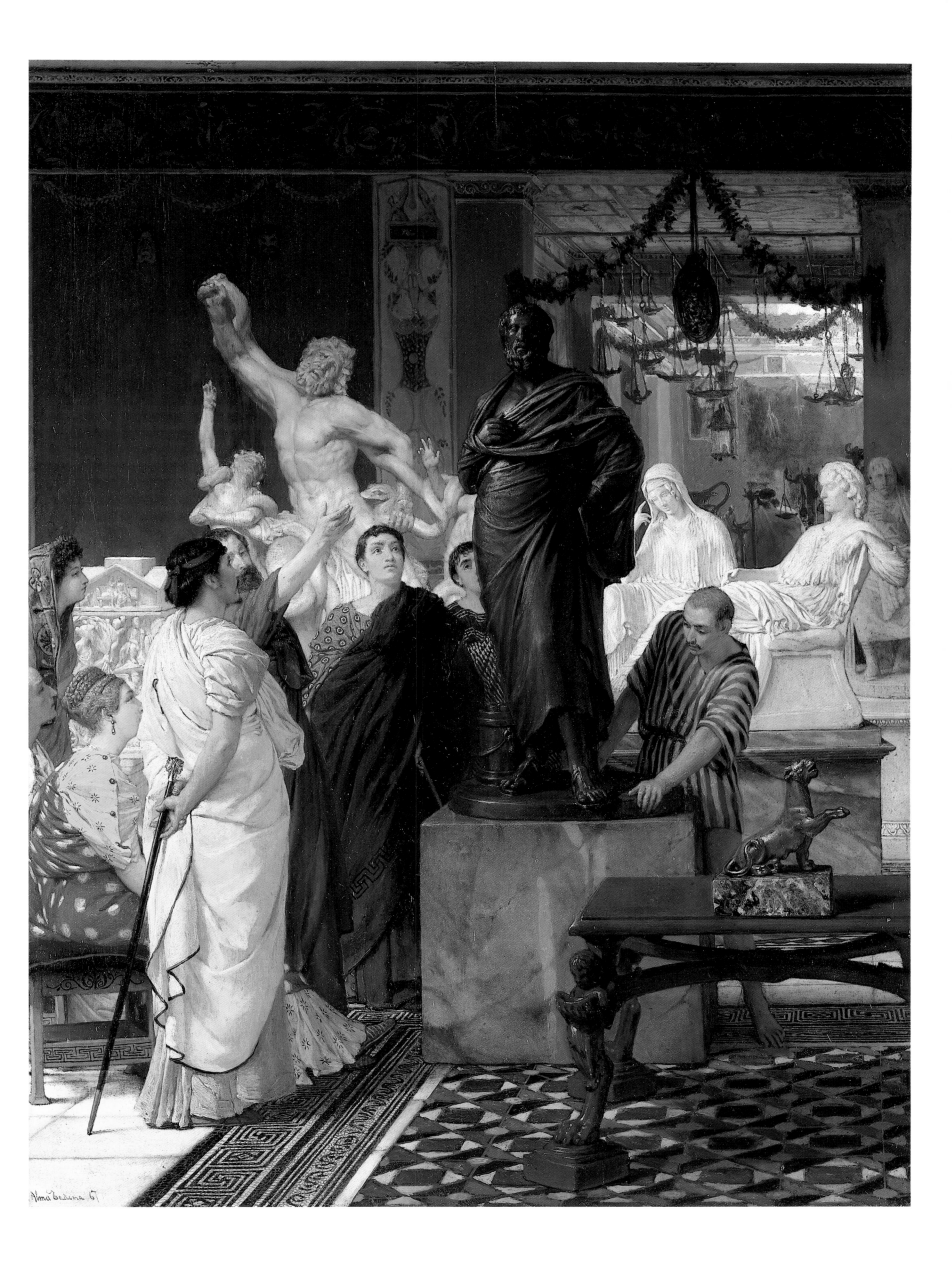

—— PLATE 2 ——

PHEIDIAS AND THE FRIEZE OF
THE PARTHENON, ATHENS

Opus LX, 1868
Oil on panel, 28⅛ × 43½ in/72 × 110.5 cm
Birmingham Museum and Art Gallery

Alma-Tadema had seen the Elgin Marbles in the British
Museum when he first visited London in 1862. At this time, a
debate was raging in academic and artistic circles as to
whether the ancient Greeks actually painted their statues and
whether contemporary sculptors should emulate them –
a concept that proved a severe culture shock to those who
equated Greek sculpture with pure whiteness. Taking
as his theme a 'private view' of the north-west corner of the
Parthenon frieze during the construction of the temple
in the 430s BC, Alma-Tadema, who had closely observed the
surviving colours, faithfully represents the frieze in all
its polychromatic glory. On the elaborate scaffolding
inspecting Pheidias's masterpiece, we see the eminent
Athenian personalities of the day: Pericles, the Athenian
magistrate, and his courtesan Aspasia; his nephew, the *enfant
terrible* Alcibiades; and behind the rope barrier, scroll in
hand, the sculptor Pheidias himself.

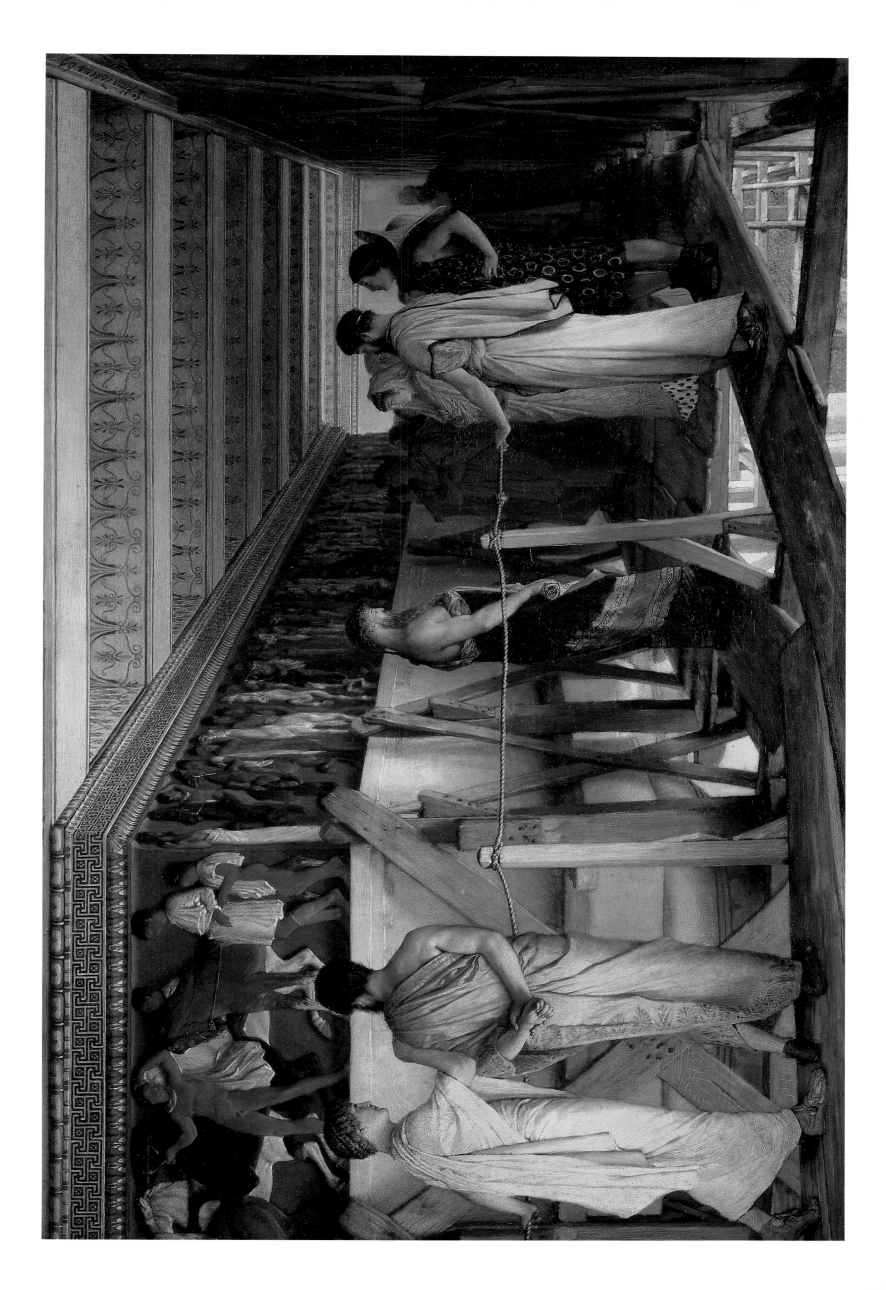

——— PLATE 3 ———

Egyptian Juggler

Opus LXXVII, 1870
Oil on canvas, 31 × 19¼ in/78.7 × 48.9 cm
Private collection

We are here invited to attend an elegant 'At Home'
in an elaborate Pompeian house, where the focus of the
entertainment is in the shade of a splendid peristyle
courtyard, the ornate Corinthian capitals and richly painted
wall and ceiling decoration pointing to the rank of the
host. The performance of the itinerant Egyptian entertainer
who gives the painting its title scarcely seems to be
exciting his audience, and, as in many of Alma-Tadema's
works, the human cast appears almost incidental to
the luxury of the surroundings. In the background there is a
picture of Bacchus and his followers; truncated by the
columns is a statue of a stag from the Villa of Papyri near
Herculaneum, and on the left a bronze group (now in
the National Archaeological Museum, Naples) showing the
infant Hercules wrestling with snakes. Alma-Tadema
visited Naples every year, and his sketchbooks were filled
with reference pictures of such treasures. Here too we
see one of his cleverly designed studio sofas, with Pompeian
motifs on one side, and Egyptian on the other, that
reappears in many works. After Alma-Tadema's death one
was sold with the contents of his house and is now in
the Victoria & Albert Museum.

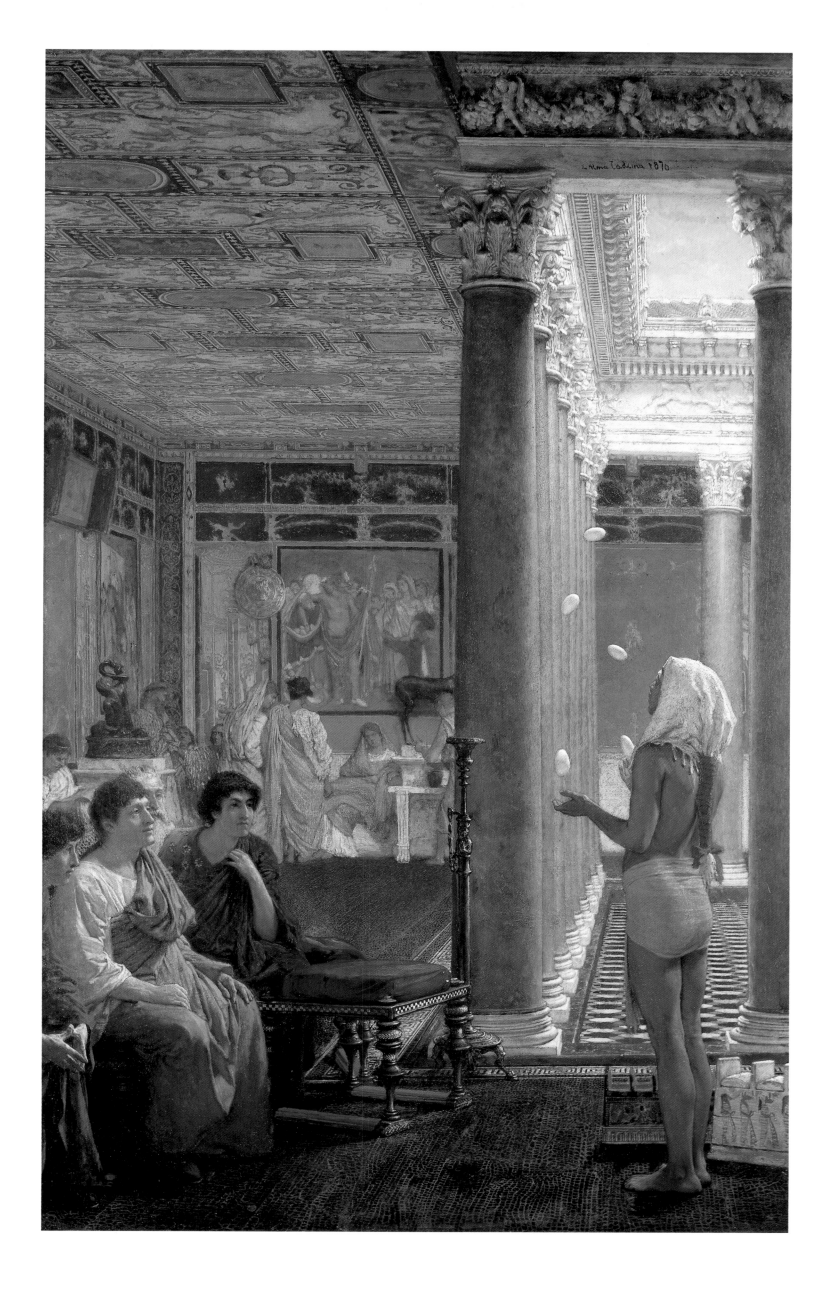

——— PLATE 4 ———

The Vintage Festival

Opus LXXXI, 1870
Oil on canvas, 30¼ × 68½ in/76.8 × 174 cm
Hamburger Kunsthalle

With ever-increasing confidence, by the 1870s Alma-Tadema
was painting some of his most complex pictures,
brimming with archaeological paraphernalia. *A Vintage
Festival*, one of the last paintings he completed before
he moved permanently to London, shows a procession in
Pompeii devoted to Dionysos or Bacchus, the god of
wine. The inscription on the floor relates to 'Marcus
Holconius' – the Holconii family was one of the
foremost in Pompeii. On a bacchic altar stands a bronze
tripod with a blazing offering, below which a silver
bucket, or *situla*, contains the sacrifice of wine. Hanging on
the pilaster to the left is a wall-painting of Bacchus and
his followers, identical to that in *An Egyptian Juggler*, beneath
which is a metal plaque representing a curious votive
offering in the hope of a cure for a diseased leg. To the far
left of the picture there is a marble statue of a drunken
satyr and, behind, a large ornamental marble *volute-krater*
embellished with scenes of bacchic revelry. On the
far right a group of silver wine vessels includes an *askos*
(pouring vessel) of exaggerated size, near which lies
a *thyrsus*, the pine cone-topped ivy-rod carried by devotees of
Bacchus. The procession is led by a priestess crowned
with vine leaves and grapes, behind whom is a troupe of
musicians – females with double-pipes or *auloi*, and
behind them two dancers with *tympana*. The men carry
amphorae of wine, followed by a *liknon*, or winnowing
basket, which customarily contained grapes and the mystic
phallus of the bacchic rites. As with many of Alma-Tadema's
procession scenes, there is little impression of movement,
but in the background there are hints of the more frenzied
celebrations to come.

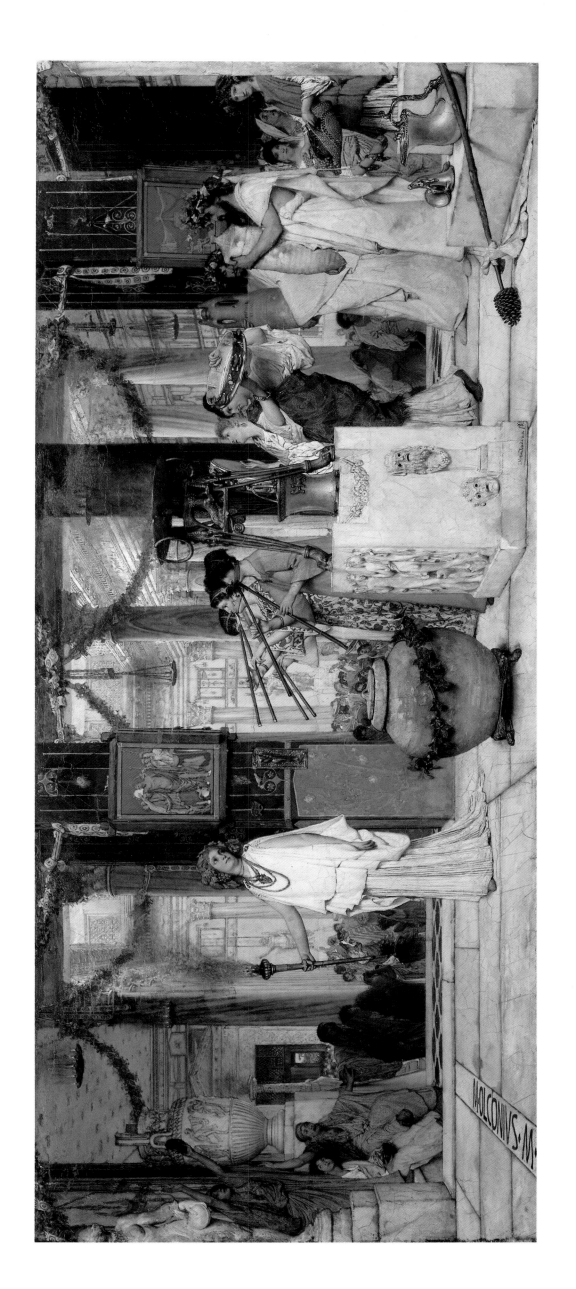

——— PLATE 5 ———

JOSEPH, OVERSEER OF PHAROAH'S GRANARIES

Opus CXXIV, 1874
Oil on panel, 13 × 17 in/33 × 43.2 cm
Private collection

By 1874 Alma-Tadema had become a naturalized British
citizen, had settled in the first of his London palaces, and was
increasingly acknowledged as one of Britain's leading
artists. It was to be one of his most prolific years, in which he
produced no fewer than twenty-one paintings – an
output that was not even stalled by the disaster in October
that wrecked his house. Egyptian subjects featured
in Alma-Tadema's repertoire after his *The Sad Father* (1859),
but were steadily eclipsed as he concentrated increasingly
on Roman themes. Apart from several later representations
of Cleopatra, *Joseph, Overseer of Pharaoh's Granaries* was
one of the last of his paintings set in Egypt until he returned
to it with *The Finding of Moses* thirty years later. When
this work was exhibited at the Royal Academy in 1874, the
art critic of the *Athenaeum* described it thus: 'Joseph,
wearing one of those wonderful Egyptian wigs, sits in state,
giving orders, and taking note of the labours of the
servants; his costume is of white tissue, painted with
charming fidelity, richness and brilliancy. A secretary
squats on the floor reading from a scroll: a capital figure.'
The writer Gerard Manley Hopkins visited the Royal
Academy and wrote in his notebook that *Joseph* was
'. . . merely antiquarian, but excellent in that way'. It
clearly draws heavily on the innumerable sketches of
Egyptian motifs that Alma-Tadema had been
systematically collecting in his scrapbooks. By now, it may be
noted, he was adding the Opus number rather than
the date beside his signature – a practice that made his
exhibited paintings 'timeless' and, since every work
now bore a unique serial number, forgery became virtually
impossible.

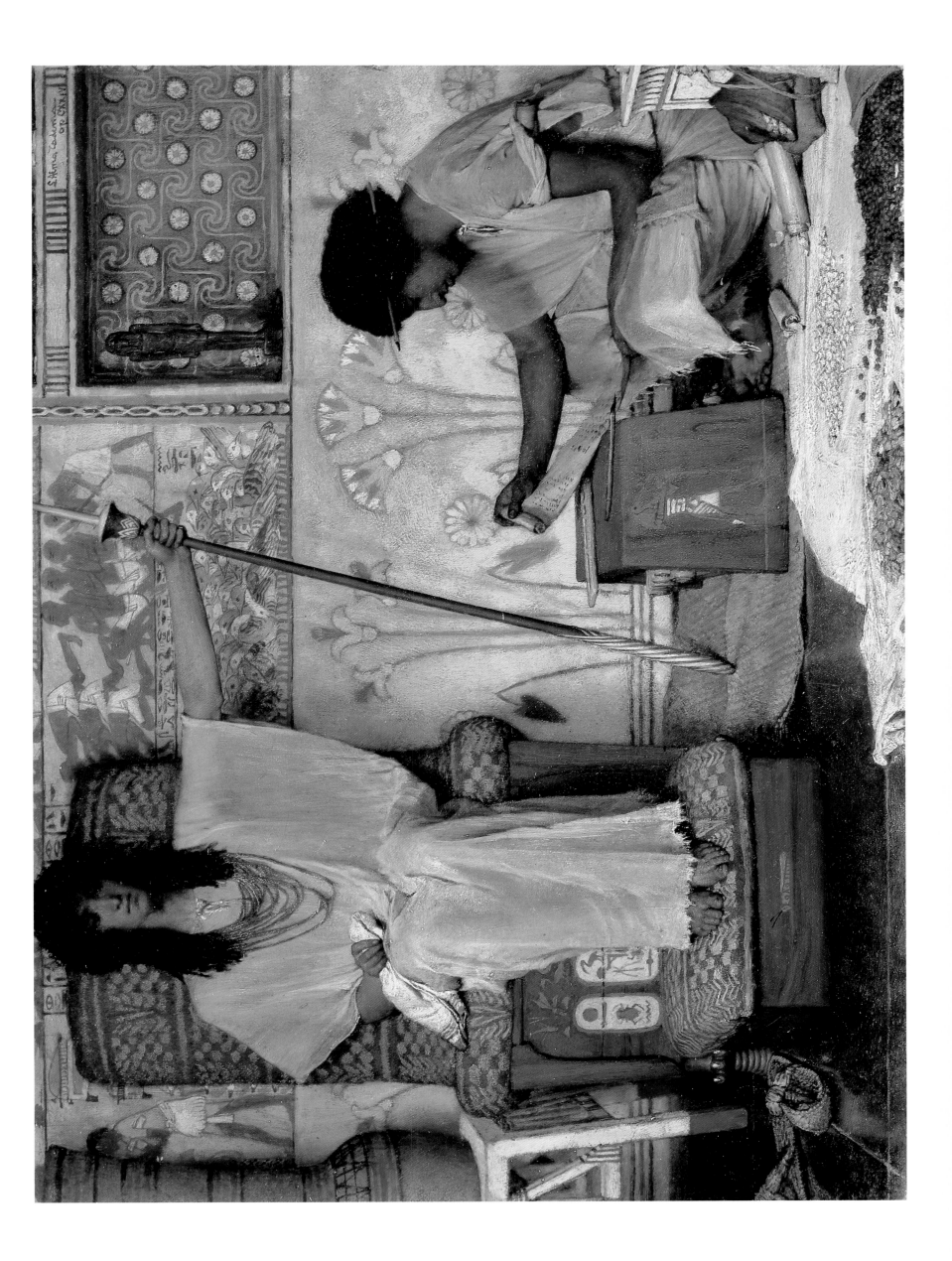

——— PLATE 6 ———

NINETY-FOUR DEGREES IN THE SHADE

Opus CLXIV, 1876
Oil on canvas, 14 × 8½ in/35.6 × 21.6 cm
Fitzwilliam Museum, Cambridge

Alma-Tadema had visited London in 1869 to be operated on
by Sir Henry Thompson (a specialist in urological
complaints who also operated on King Leopold I of Belgium
and Napoleon III). Thompson had aspirations as an
artist, and Alma-Tadema became his teacher and a close
friend. When they holidayed together on the doctor's
houseboat in 1875, Alma-Tadema painted portraits of
Sir Henry and his son, Herbert (later an eminent
Egyptologist), on the door panels. Only very occasionally did
he depart from his lifelong concern with the ancient
world, his portraits of contemporary figures being among his
only works in which his subjects appear in modern
dress. He painted *Ninety-four Degrees in the Shade* after harvest
on the edge of a cornfield near Godstone, Surrey.
A small and untypically Impressionistic picture (painted
within two years of the Impressionists' first Paris
exhibition), it depicts seventeen-year-old Herbert Thompson
as a young lepidopterist in Victorian summer kit of
sola topi-style hat and linen suit, intently consulting a
reference book, his butterfly net lying beside him on
the ground. As with many of his more characteristic
paintings, Alma-Tadema has adopted an unconventional
viewpoint, looking down on the prostrate figure.

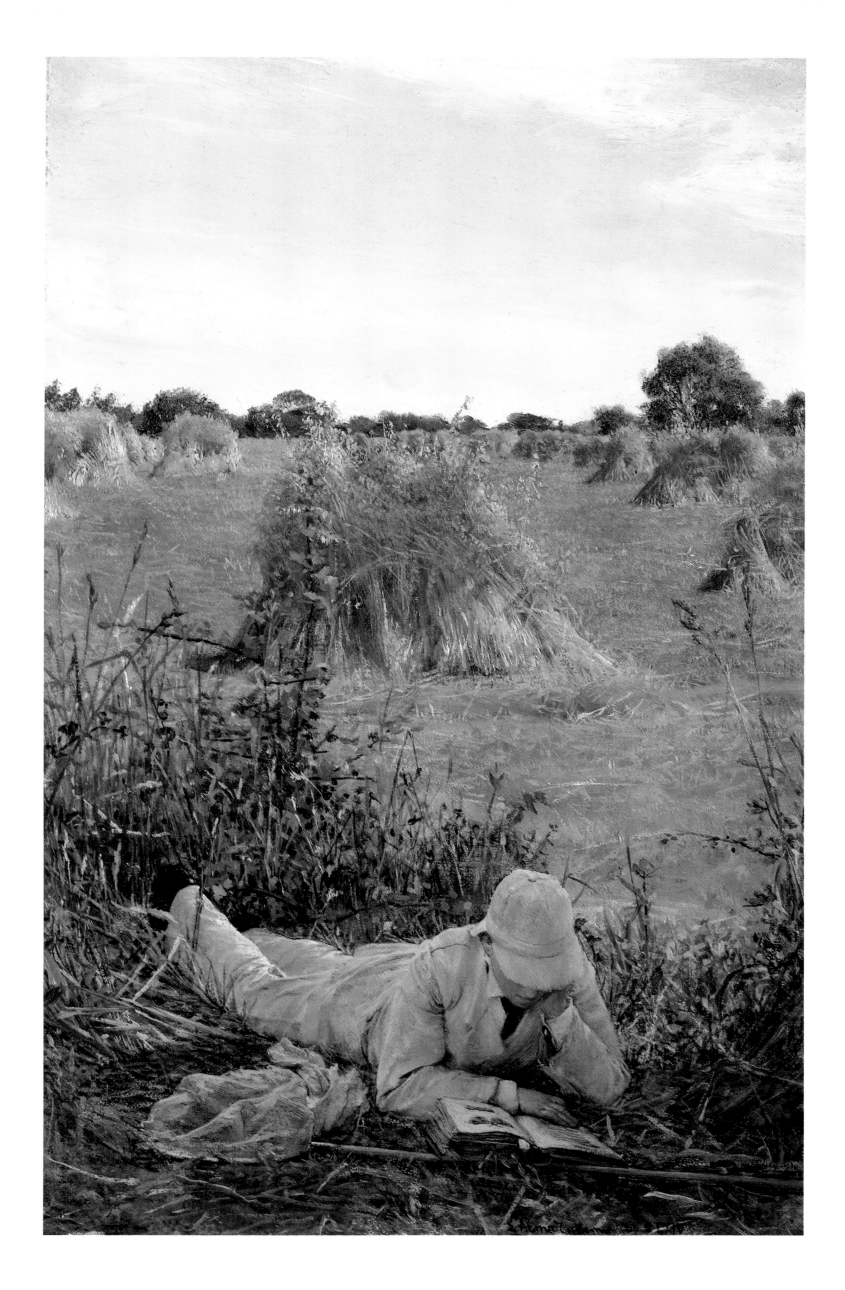

———— PLATE 7 ————

FLORA: SPRING IN THE GARDENS
OF THE VILLA BORGHESE

Opus CLXXXVII, 1877
Watercolour, 11¾ × 8 in/29.9 × 20.3 cm
Private collection

In 1877 Alma-Tadema painted a series of paintings, one on
each of the four seasons, taking as his setting the gardens
of the Villa Borghese, Rome. As well as demonstrating his
considerable skill in the alternative medium of watercolour,
Flora exemplifies two of his working methods that are
increasingly encountered. Firstly, he often executed several
versions of the same work, usually with variant details,
in different sizes or media. This was in fact the fourth of four
versions of the subject; the other three were all in oils,
the first of them destroyed during the Second World War,
the second now in the Madison Art Center, Wisconsin,
and the third, painted on a door panel for Hendrik Willem
Mesdag, and to be seen today in the Mesdag Museum
in The Hague. Secondly, one small element of a painting was
often taken, adapted and worked up into another picture
in its own right – in this instance, the scene in the right
background where a woman sits upon a marble bench
or *exedra*, while a man lies alongside, his head cupped in one
hand. Under the title, *Pleading*, the composition had
already appeared (reversed, left to right) the previous year,
and was to reappear in such works as, in 1877, *The
Question* and, in 1883, *Xanthe and Phaon* (the 'question' was
whether Xanthe should marry Phaon). Alma-Tadema's
mentor, the Egyptologist Georg Ebers, was inspired to write
a novel based on the theme of these paintings.

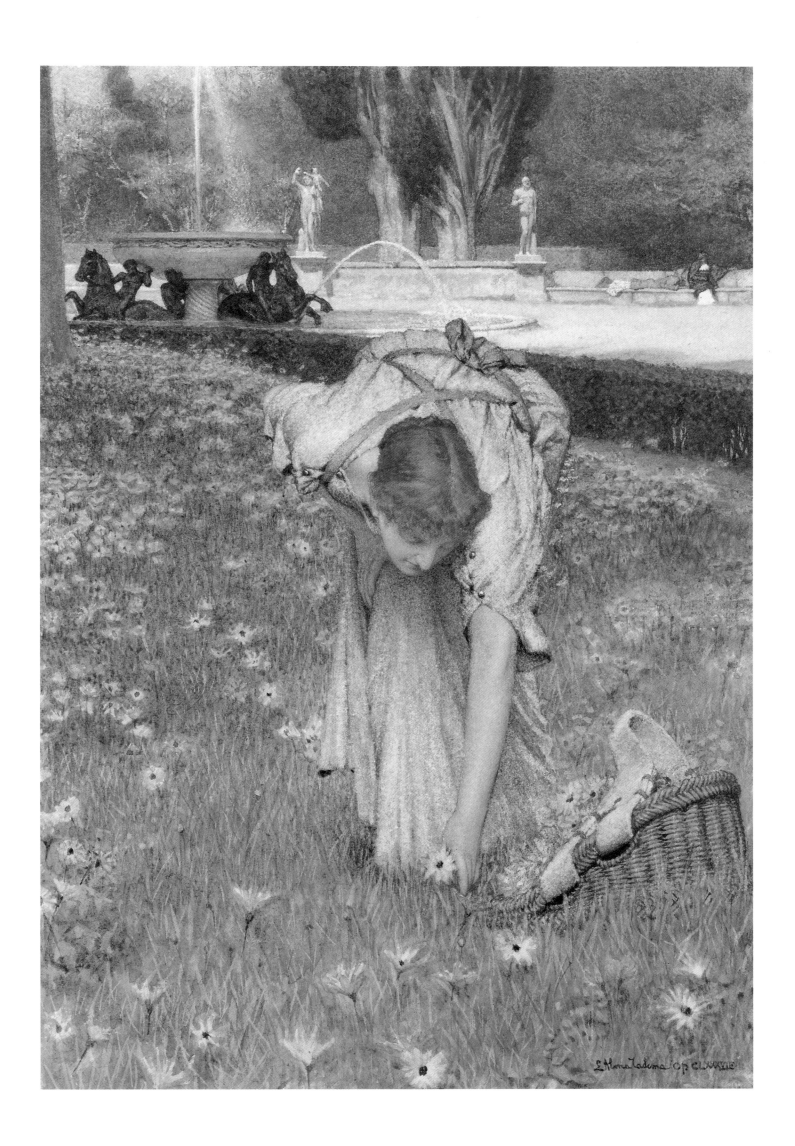

—— PLATE 8 ——

A Hearty Welcome

Opus CXC, 1878
Oil on canvas, 12 × 36½ in/30.5 × 92.7 cm
Ashmolean Museum, Oxford

Alma-Tadema aspired to feature on canvas the Pompeii that
Bulwer-Lytton had described in his 1834 novel, *The Last
Days of Pompeii*, including the minutiae of daily life. Also
known by the alternative title, *A Roman Garden*, *A Hearty
Welcome* was painted for his doctor, pupil and friend, Sir
Henry Thompson. On the surface it is a scene in a
Pompeian courtyard, showing a *larrarium*, or household
shrine, a sundial on the wall and a well-tended garden
filled with poppies – and uncharacteristically anachronistic
sunflowers, since they were unknown in Europe until
brought from the Americas. The painting is in fact a more
personal memento of the friendship between the
Alma-Tadema and Thompson families, for the woman in the
garden is Laura Alma-Tadema and the two girls her
stepdaughters, Laurence and Anna, while descending the
staircase is the painter himself. He had previously
depicted himself with his first wife and their daughters as a
Roman family, and increasingly featured them as well
as the family's friends alongside professional models.

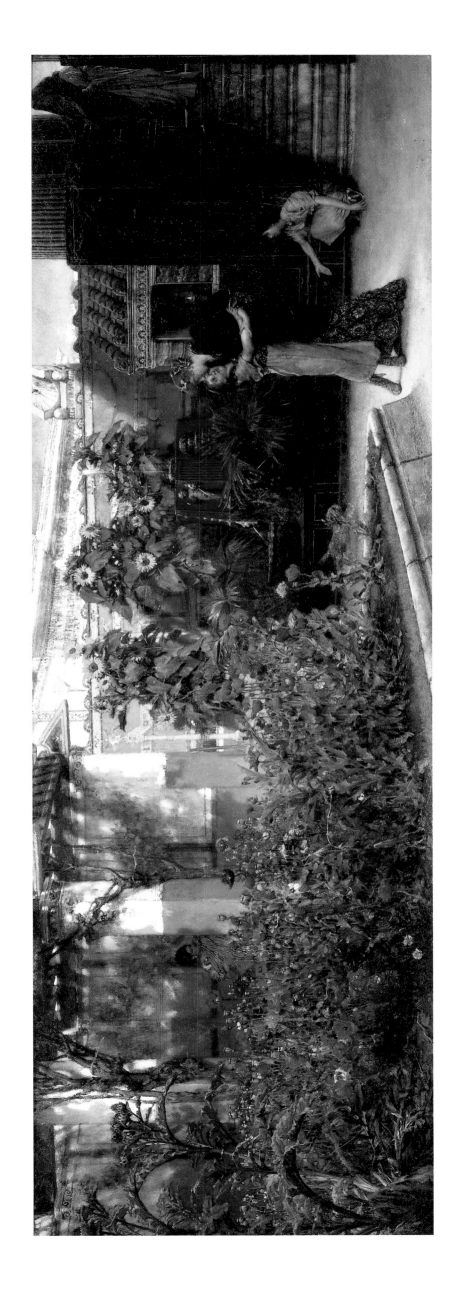

——— PLATE 9 ———

STRIGILS AND SPONGES

Opus CXCVII, 1879
Watercolour, 12½ × 5½ in/31.8 × 14 cm
The British Museum, London

Alma-Tadema again turned to his wife as a convenient model
for this more risqué subject (she is the woman in the
foreground). It shows a cold water plunge-bath in a Roman
bath-house with an elaborate fountain depicting Eros
encircled by a dolphin, based on an original in the National
Archaeological Museum, Naples. As well as their sponges,
the women use strigils, or body scrapers, but the procedure
was perhaps not as implied by this subject. Typically,
Roman athletes would protect their bodies from the rays of
the sun by applying a barrier consisting of a layer of
oil and dust. After exercising, this was scraped off with a
strigil and the body rinsed with water. The strigil was
thus more probably a masculine object used prior to bathing,
and not the feminine bath accessory as Alma-Tadema
often featured it in this and works such as *In the Tepidarium*,
A Fountain and other bathing scenes. This watercolour,
now in the British Museum, is mounted together with his
engraver Paul Adolphe Rajon's preparatory etching
heavily annotated by Alma-Tadema, demonstrating both
what a meticulous and an exasperatingly demanding
craftsman he could be.

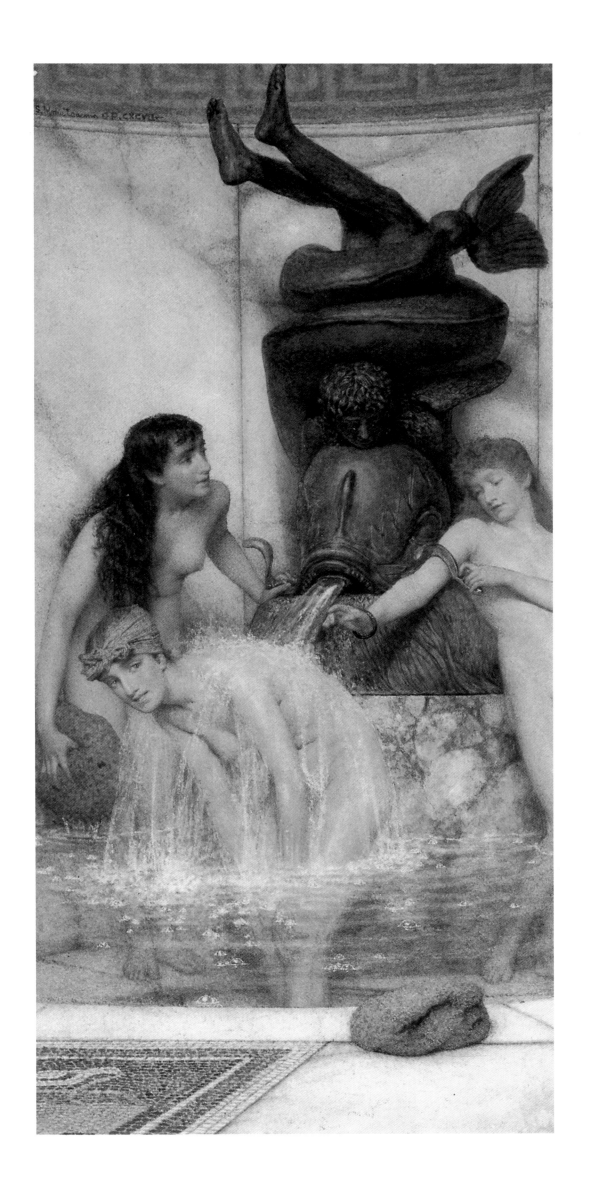

——— PLATE 10 ———

SAPPHO AND ALCAEUS

Opus CCXXIII, 1881
Oil on canvas, 26 × 48 in/66 × 122 cm
The Walters Art Gallery, Baltimore

Regarded in his day as one of Alma-Tadema's most successful
paintings, *Sappho and Alcaeus* depicts two famous Greek
lyric poets. Sappho lived in Mytilene on the island of Lesbos
in the 6th century BC with a company of girls dedicated
to the cult of Aphrodite and the Muses. Her love for them
gave rise to the word 'lesbian', which Alma-Tadema
hints at with the gentle show of affection of the girl beside
Sappho, who sits at a lectern of the painter's invention.
Alcaeus, an aristocratic poet, also came from Lesbos and was
a friend of Sappho who is here shown entranced by his
recital. Alcaeus sits opposite her in a Greek *klismos* chair. He
accompanies his song on a stringed instrument known
as a *kithara* painted with a scene representing Apollo, God of
Music, and his sister, Artemis, both of whose names are
inscribed. The setting is a corner of an *odeion*, a building used
for musical performances, sited by the sea, the design
of which appears to be based on a Greek vase-painting much
reproduced at the time Alma-Tadema was working,
but which is now discredited as a fabrication.

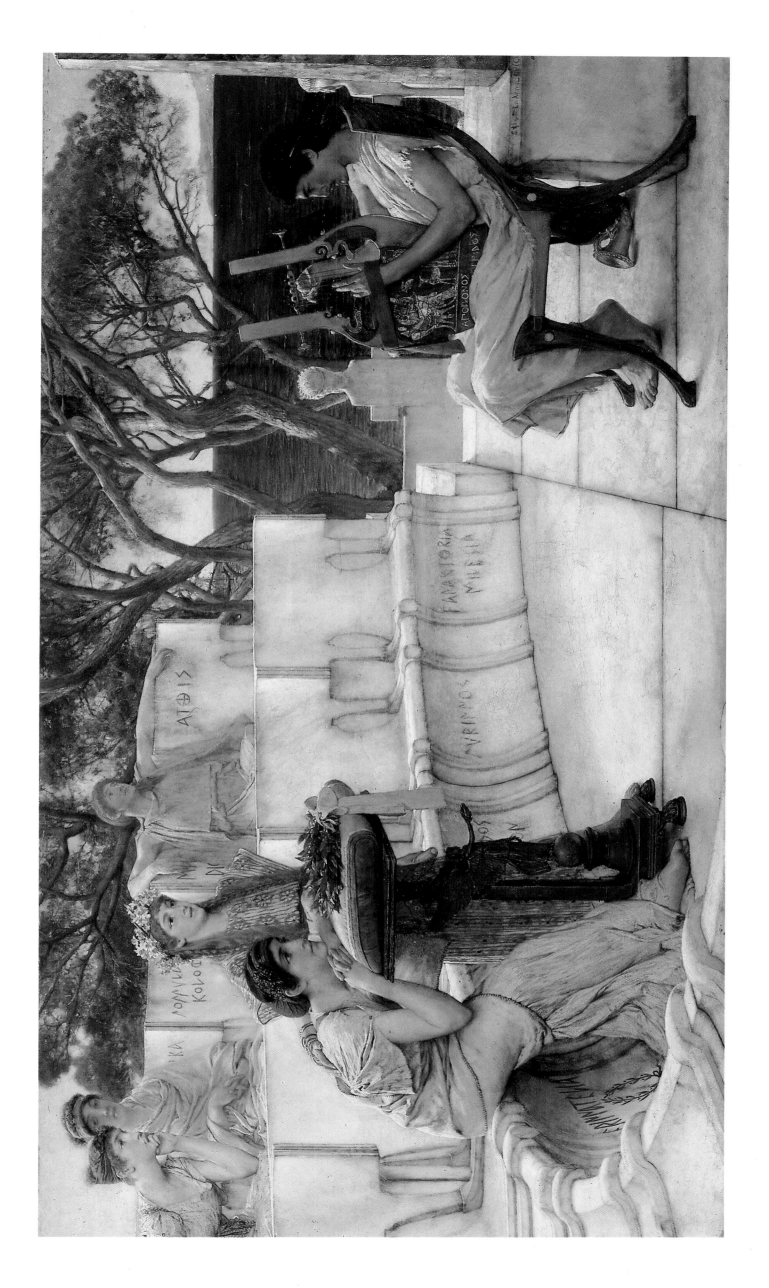

———— PLATE 11 ————

IN THE TEPIDARIUM

Opus CCXXIX, 1881
Oil on panel, 9½ × 13 in/24.1 × 33 cm
The Lady Lever Art Gallery, Port Sunlight

This relatively small painting shows a woman lying
on a bearskin in a tepidarium, a chamber
between the hot and cold rooms in a Roman bath,
exemplifying Alma-Tadema's skill in depicting,
almost in miniature, textures such as fur, feathers
and flesh. Hailed as his most erotic *tour de
force*, the sultry model's pose, her parted lips, the
phallic strigil and the teasing attitude of the
ostrich-feather fan are far more 'provocative' (as the
Bishop of Carlisle commented about *A Sculptor's
Model*) than, for example, Manet's *Olympia* or
Déjeuner sur l'Herbe. The latter were attacked,
however, less because they depicted nudes than
because they were avowedly contemporary.
The very title of *In the Tepidarium*, the presence of an
oleander in a Roman bronze container, the
strigil itself and the marble, on the other hand, all
remind us that this was a classical scene which
was thus beyond reproach.

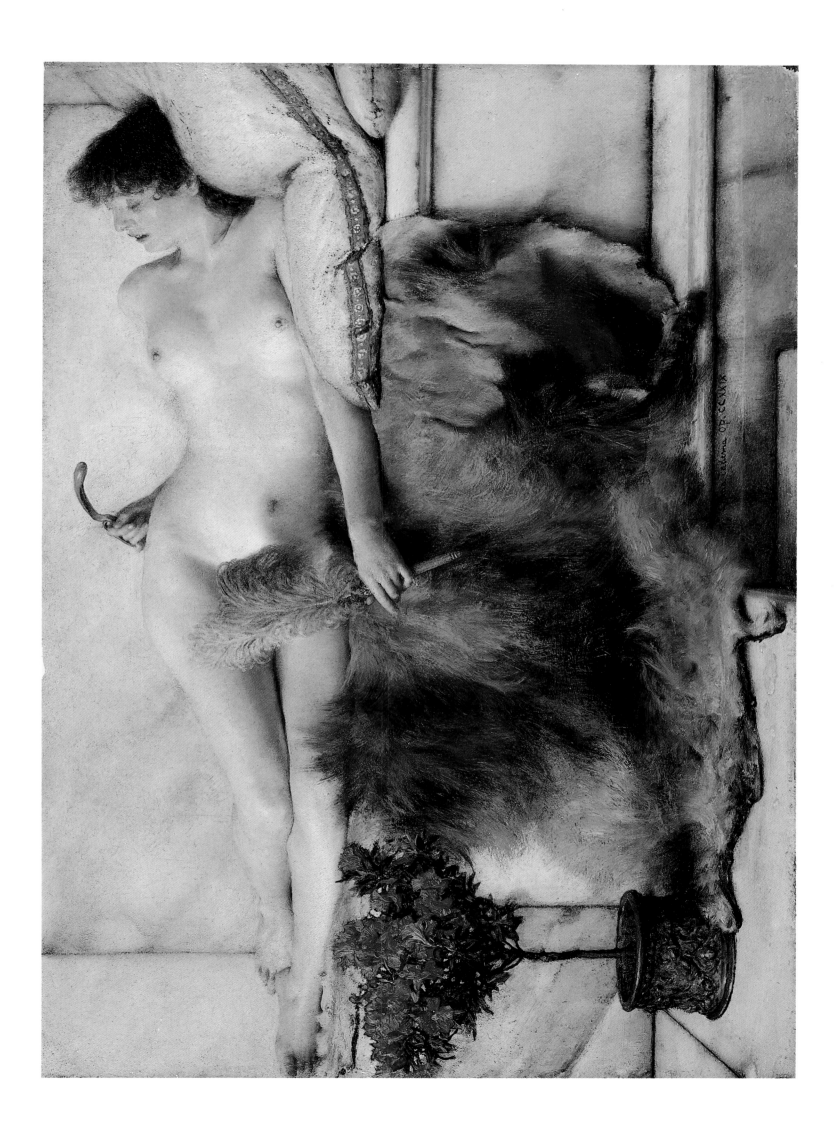

——— PLATE 12 ———

THE PARTING KISS

Opus CCXL, 1882
Oil on panel, 44½ × 29 in/113 × 73.7 cm
Private collection

According to his biographer Percy Cross Standing, *The Parting
Kiss* was one of Alma-Tadema's favourite paintings. It
features a woman bidding her daughter farewell as she leaves
for the amphitheatre that we see in background. The
Roman lady beneath the umbrella in the carriage at the door
was modelled by Laura Alma-Tadema. In the street are
others making their way to the same venue, one accompanied
by a slave bearing cushions, a reminder by the artist
that Romans, like his fellow-Victorians, loved their comfort.
The word *salve*, welcome, is inscribed at the entrance –
as it was at the door of Alma-Tadema's own house in St John's
Wood. He revelled in packing his paintings with artefacts,
but was aware of critics of his technique. 'The people of
today,' he commented, 'will tell you that all this minute
detail is not art! But it gives so much pleasure to paint him
[sic] that I cannot help think it will give at least someone
pleasure to look at him too.' Somewhat confusingly, when
this painting was restored, it acquired the incorrect
Opus number, 'CCXLI'. Several other Alma-Tadema paintings
have suffered similar depredations at the hands of
clumsy restorers.

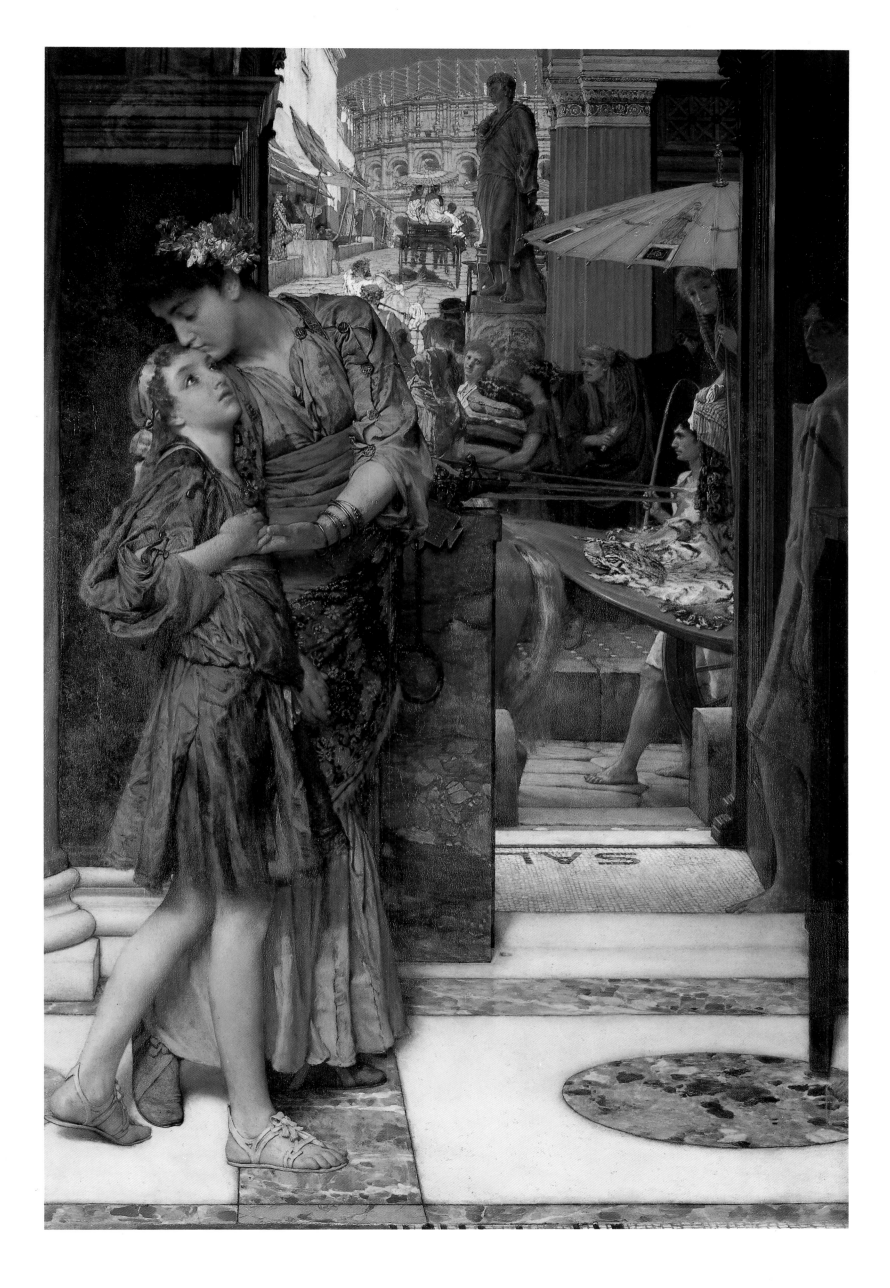

————— PLATE 13 —————

Antony and Cleopatra

Opus CCXLVI, 1883
Oil on panel, 25¼ × 36¼ in/65.4 × 92.1 cm
Margaret Brown Collection

In 1875 and 1877 Alma-Tadema had painted profiles
of Cleopatra, Queen of Egypt, modelled on a
bust of her mother, Berenice. From these preparatory
portraits, he developed his idealized complete
figure, depicting her as she awaits the arrival of
Mark Antony on her royal barge. She is holding
the insignia of her rank, the flail and crook, and sits
serenely on a throne flanked by figures of
baboons. Alma-Tadema follows Shakespeare, where
the vessel is vividly described by Domitius
Enobarbus, who refers to her cloth-of-gold pavilion,
the flautists and the 'strange invisible perfume' –
which Alma-Tadema explains by showing slaves
wafting incense through the canopy. Beyond, a
fleet of triremes looms into view as Antony prepares
expectantly to come aboard.

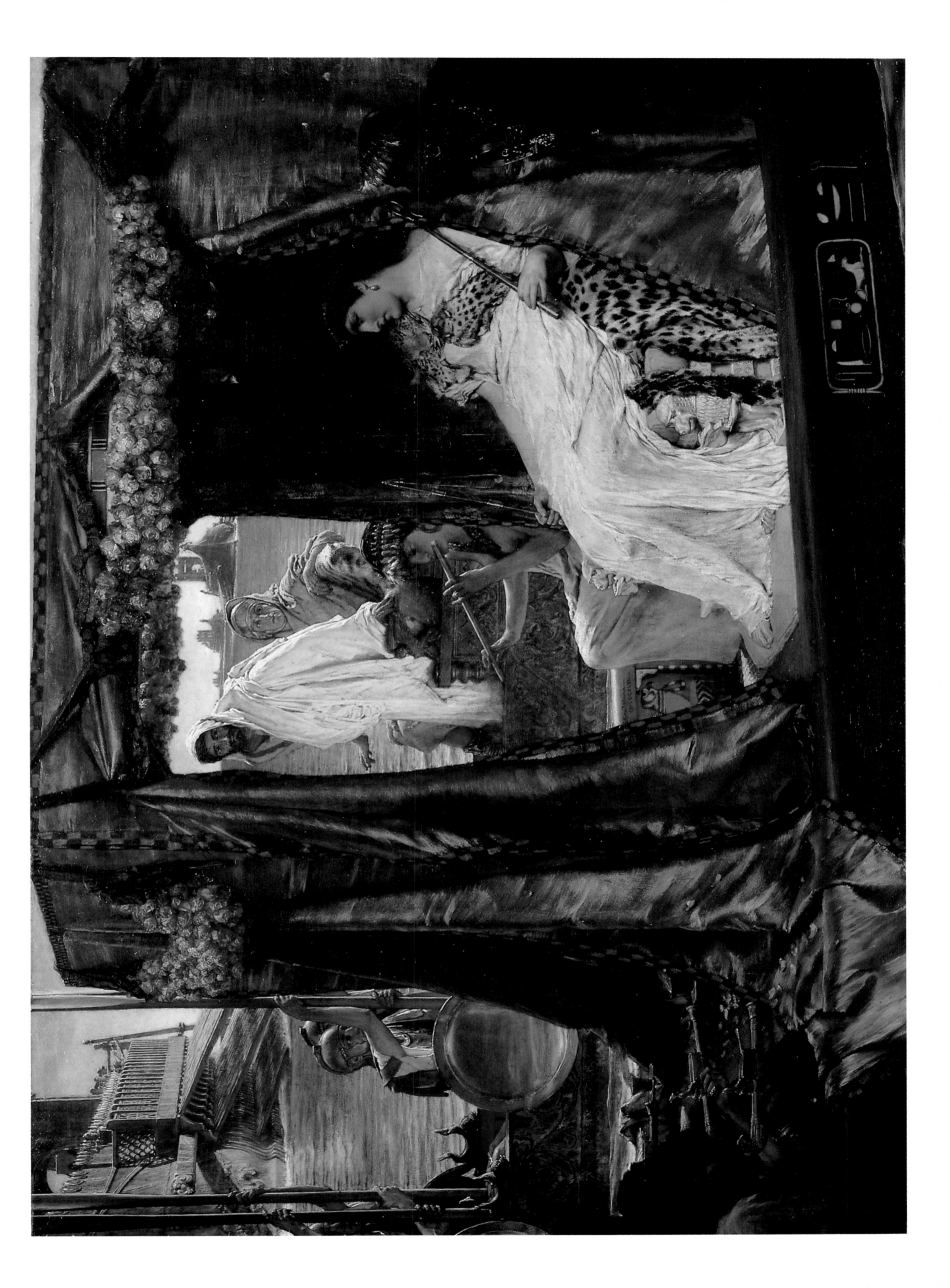

—— PLATE 14 ——

WELCOME FOOTSTEPS

Opus CCLVII, 1883
Oil on canvas, 16½ × 21½ in/41.9 × 54.6 cm
Private collection

Specific historical events and named characters became
increasingly rare in Alma-Tadema's work as timeless
anecdotal subjects took precedence. The theme of a
rendezvous of two lovers was perhaps his most dominant
single subject from the 1880s onwards. From this
period, women sit in eager expectation of the arrival of a
suitor in paintings with titles such as *Watching and
Waiting* or *Who Is It?* Perhaps, as here, his appearance is
imminent, or he has just arrived, as in *A Silent Greeting*,
in which a man finds his lover has fallen asleep while waiting
for him; in one picture we witness a lie in the telling
as an unwanted suitor is informed, *'My Sister is Not at Home'*.
Along with this development, descriptive titles gave way
to poetic quotations and memorable clichés – *A Message of Love*,
Wandering Thoughts, *Love's Jewelled Fetter*, *Fortune's Favourite*.
From this period too in many paintings the archaeological
detail is incidental and sufficient only to remind us that
we are in ancient Rome and not attending a fancy-dress party
in modern London. In *Welcome Footsteps* a statue of a
marble faun is seen from behind and there is the tiger-skin
that features in several paintings: when Alma-Tadema
was pointing it out to a visitor in his *An Audience at Agrippa's*,
he asked, 'Can't you see him wag his tail?'

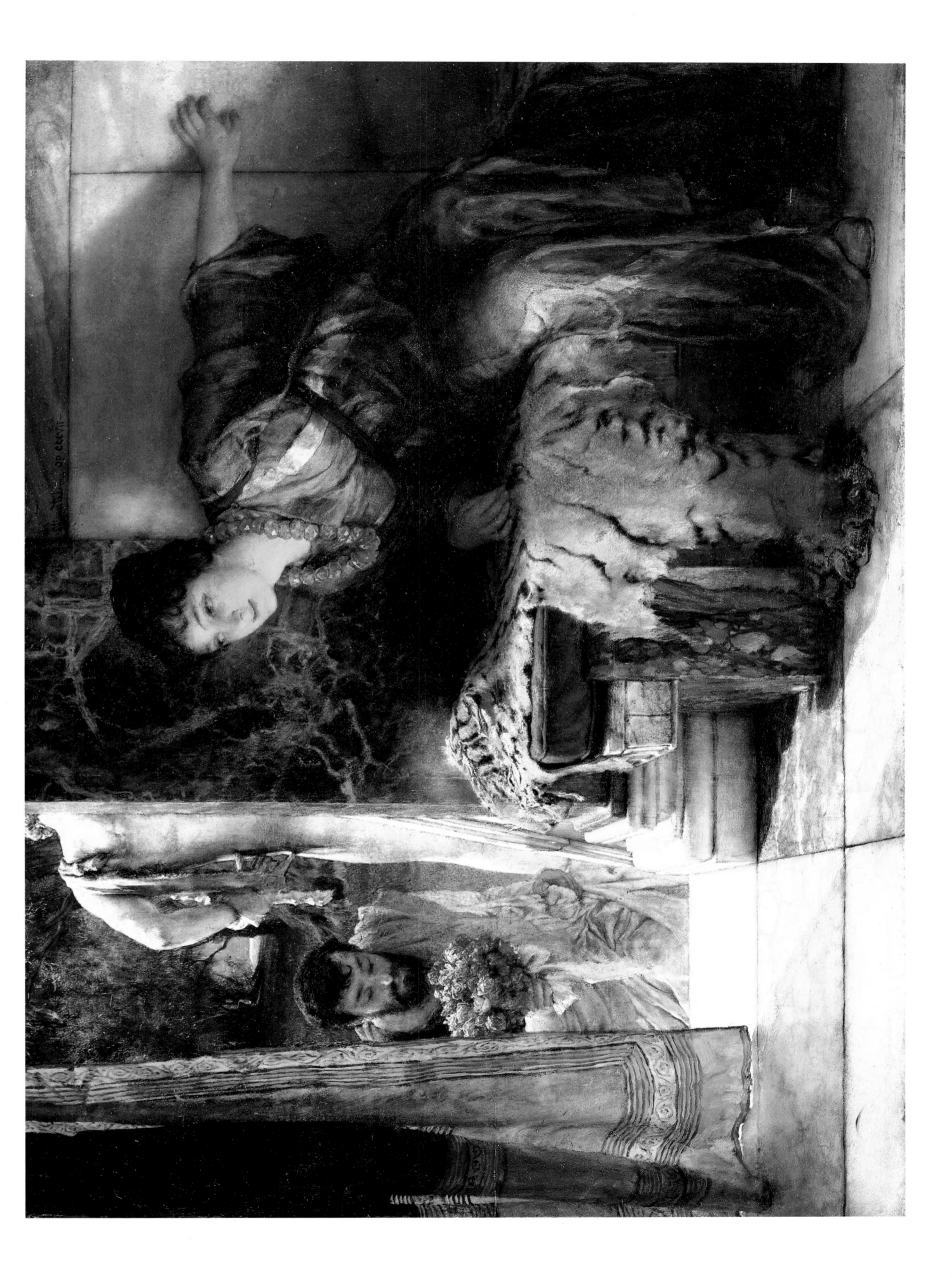

———— PLATE 15 ————

EXPECTATIONS

Opus CCLXVI, 1885
Oil on panel, 8¾ × 17¾ in/22.2 × 45.1 cm
Private collection

A critic wrote of the typical Alma-Tadema painting as
consisting of 'a sapphire sea, white-crested waves, a blue sky,
sweet-smelling flowers', to which he might have added
'and a girl on a marble bench dreaming of her lover'. In a
number of pictures painted in his last quarter-century,
these were the elements to which he was repeatedly to
return. Such works were customarily painted in the
Bay of Naples, where he often used the cliff-top setting to
dispose of the middle-ground, thereby placing the
white marble in sharp contrast against the blue of the sky and
sea behind. The stark lines of the *exedra* would often
be broken by the addition of a blossom-laden tree, as here
with a Judas-tree. Beside it the girl awaits the arrival
of her lover, for whose ship she scans the sun-drenched sea.
Together with *The Women of Amphissa*, *Expectations* won
Alma-Tadema the Gold Medal at the Paris Exposition
Universelle of 1889.

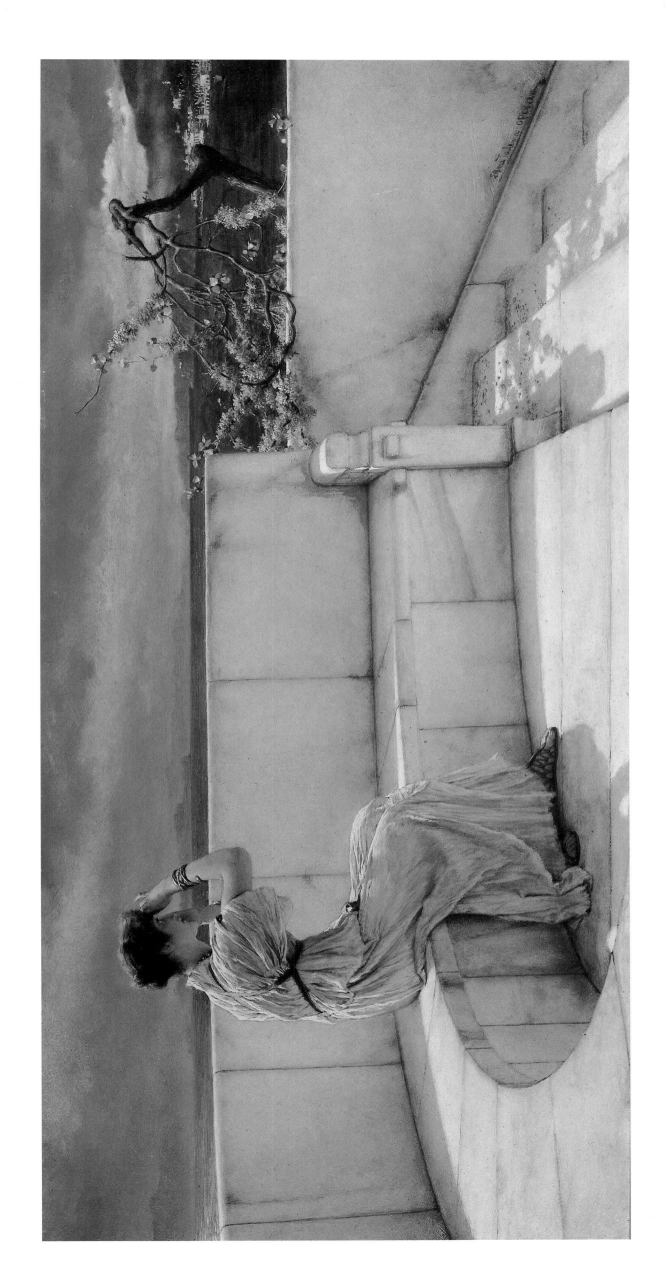

———— PLATE 16 ————

A Reading from Homer

Opus CCLXVII, 1885
Oil on canvas, 36 × 72⅜ in/91.4 × 183.8 cm
Philadelphia Museum of Art: George W. Elkins Collection

After Alma-Tadema's move to his new studio with its famed
aluminium ceiling, there was a notable enhancement
in the brightness of his paintings, of which this is an early
example. Eight months' research were said to have
been devoted to this and an abandoned companion painting,
Plato, with two months' work in its painting. The theme
and composition are redolent of *Sappho and Alcaeus*, and the
kithara is present in both works. Here we see an intimate
gathering for a recital from the epics of the poet Homer,
whose name is inscribed in Greek behind. A *rhapsode*
(professional reciter) sits before an enraptured audience.
Homer was held in great esteem by the Victorians, and
this could equally have been a soirée in a Victorian drawing
room – where the rugs would at least have been more
comfortable than the cold marble floor. According to his
biographer Helen Zimmern, *A Reading from Homer*
contained the best flesh painting he had ever done.

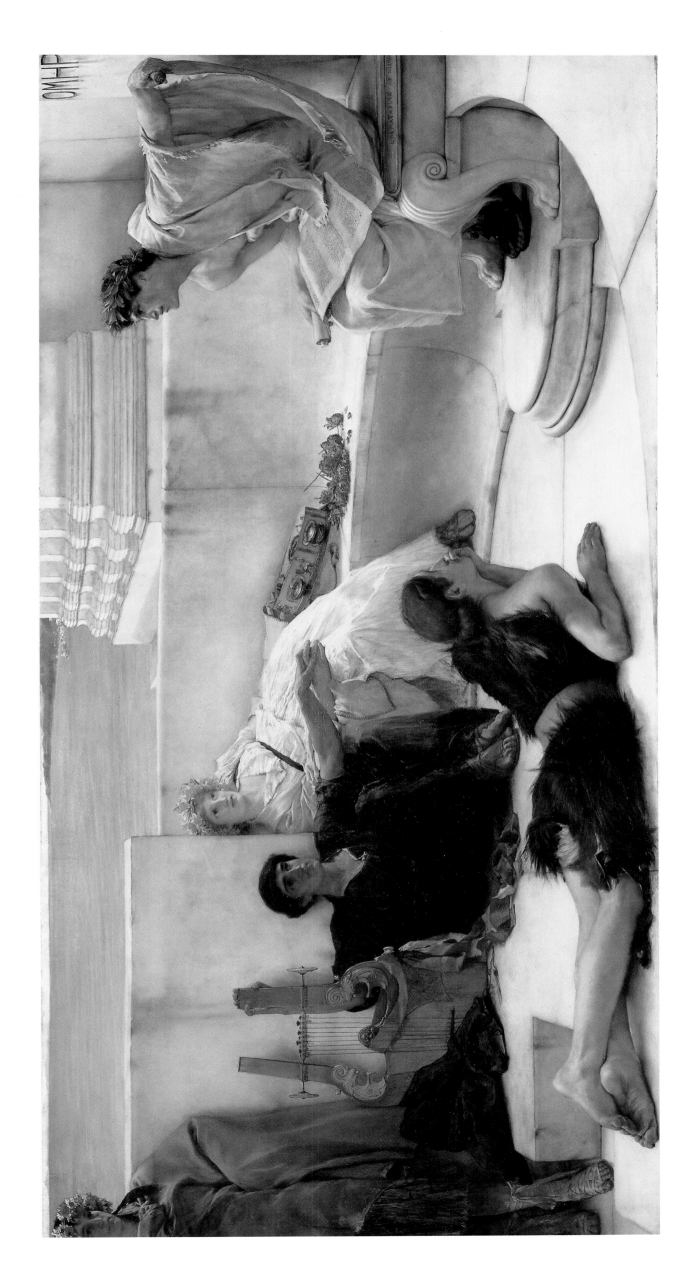

THE WOMEN OF AMPHISSA

Opus CCLXXVIII, 1887
Oil on canvas, 48 × 72 in/121.9 × 182.9 cm
The Sterling and Francine Clark Museum, Williamstown

One of Alma-Tadema's largest and most striking paintings, it
is also among the last in which he portrayèd a dated
historical event. Amphissa in western Locris commanded the
route leading west from Mount Parnassus. It was the
location of a festival held in honour of Dionysos, but in the
year 350 BC, when the territory was overrun by soldiers
from Phocis, it was feared that while exhausted by their
religious frenzy the *mænades* or bacchantes would be
vulnerable to being ravished by the soldiers. Accordingly,
when they came to Amphissa after their rites, the
women of the town surrounded them throughout the night
in order to protect them, and the following morning,
when they awoke, fed them and escorted them to safety.
Alma-Tadema portrays the Amphissan market-place
at dawn, a dozen dazed bacchantes sprawled on the ground,
gradually awakening. An assortment of south Italian
and Athenian painted verses are combined anachronistically
with a large silver *krater* from the Roman Hildesheim
treasure – Alma-Tadema is known to have owned a replica,
which features in several works. In the centre, beneath
the roundel, perhaps intended as the leader of the women of
Amphissa, is Laura Alma-Tadema.

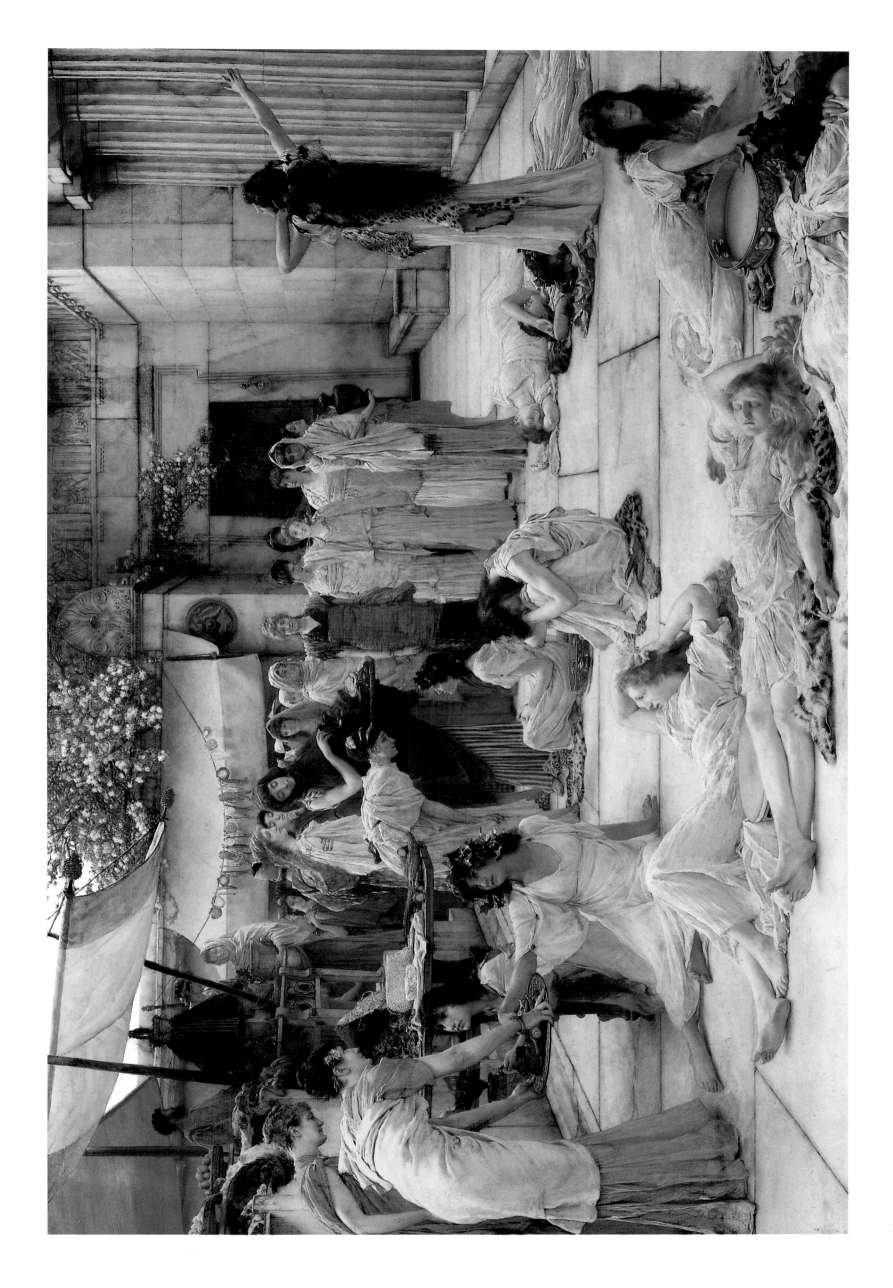

——— PLATE 18 ———

THE ROSES OF HELIOGABALUS

Opus CCLXXXIII, 1888
Oil on canvas, 52 × 84⅛ in/132.1 × 213.7 cm
Private collection

The *Magazine of Art* wrote of this painting: 'No incident could
be more happy for the painter to exercise his skill
upon, rich and delicate colouring combining marvellously
with all the possibilities of marble painting and
archaeological accessory.' The circumstances of the incident
depicted were, however, less than happy. Marcus
Aurelius Antonius, better known by his adopted name,
Heliogabalus or Elagabalus, ruled Rome briefly from
AD 218 to 222. He attempted unsuccessfully to introduce
the cult of the oriental sun-god of Emesa to Rome, and
was notorious for his oriental-style court and its extravagant
banquets at which the menu might include the brains
of 600 ostriches, powdered glass or camel dung, such was the
Emperor's perverted sense of humour. By the time he was
eighteen, he was murdered by the Praetorian guard, his body
dragged through the streets and hurled into the Tiber.
Among his celebrated practical jokes was the releasing of a
canopy over his guests, suffocating them beneath tons
of rose petals, which Alma-Tadema depicts with the
debauched emperor and his world-weary companions
gazing at the scene in detached amusement. In the background
stands a statue (now in the Vatican) of Dionysos with
a panther at his feet and a young faun companion, a subtle
token of the 'forbidden love' that was numbered among
the emperor's excesses. In order to paint the roses precisely
during the winter, he had them sent from the French
Riviera, and for months afterwards Alma-Tadema's studio
floor was littered with rose petals.

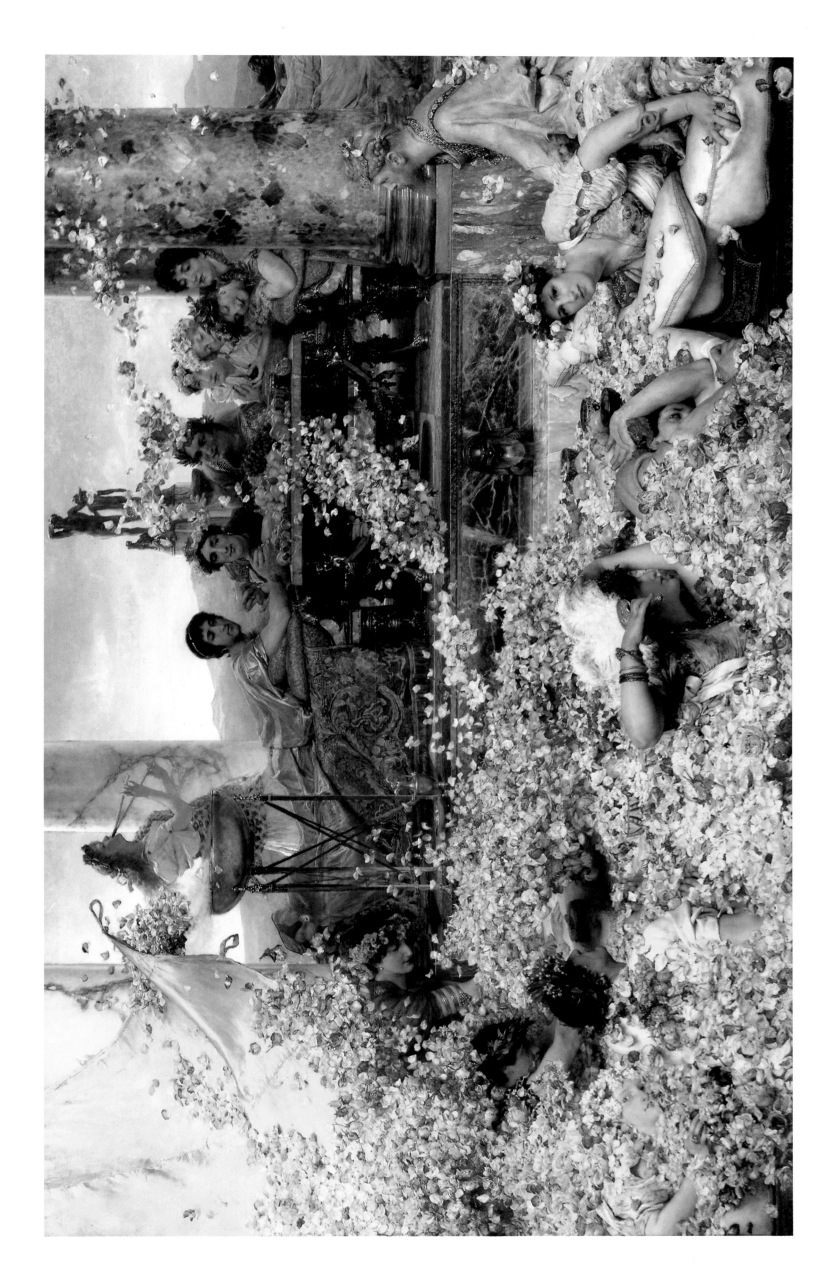

—— PLATE 19 ——

The Favourite Poet

Opus CCXC, 1888
Oil on panel, 14½ × 19½ in/36.8 × 49.5 cm
The Lady Lever Art Gallery, Port Sunlight

One girl reads verses from a scroll while another listens
dreamily. Behind, roundels depicting the muses, including
Thalia, Urania and Polyhymnia, reiterate the literary
context, but it is inevitably incidental to the true purpose of
the work, which is to portray two beautiful women
revelling in the luxury of their leisured lifestyle. The
composition was so successful that it was repeated
with modifications in such works as *Comparisons*. The models'
poses are similar to those of his contemporary, Albert
Moore, who also depicted languid women in Greek and
Roman settings, in or out of costume – though his aims
were so much more aesthetic than antiquarian that he was
untroubled by showing an ancient Roman playing a
violin. The fundamentally Hellenic costumes worn by
Alma-Tadema's models were designed with such
attention to detail that some were copied and sold by such
firms as Liberty's and others used as stage costumes
by famous actresses of the day, including Ellen Terry.

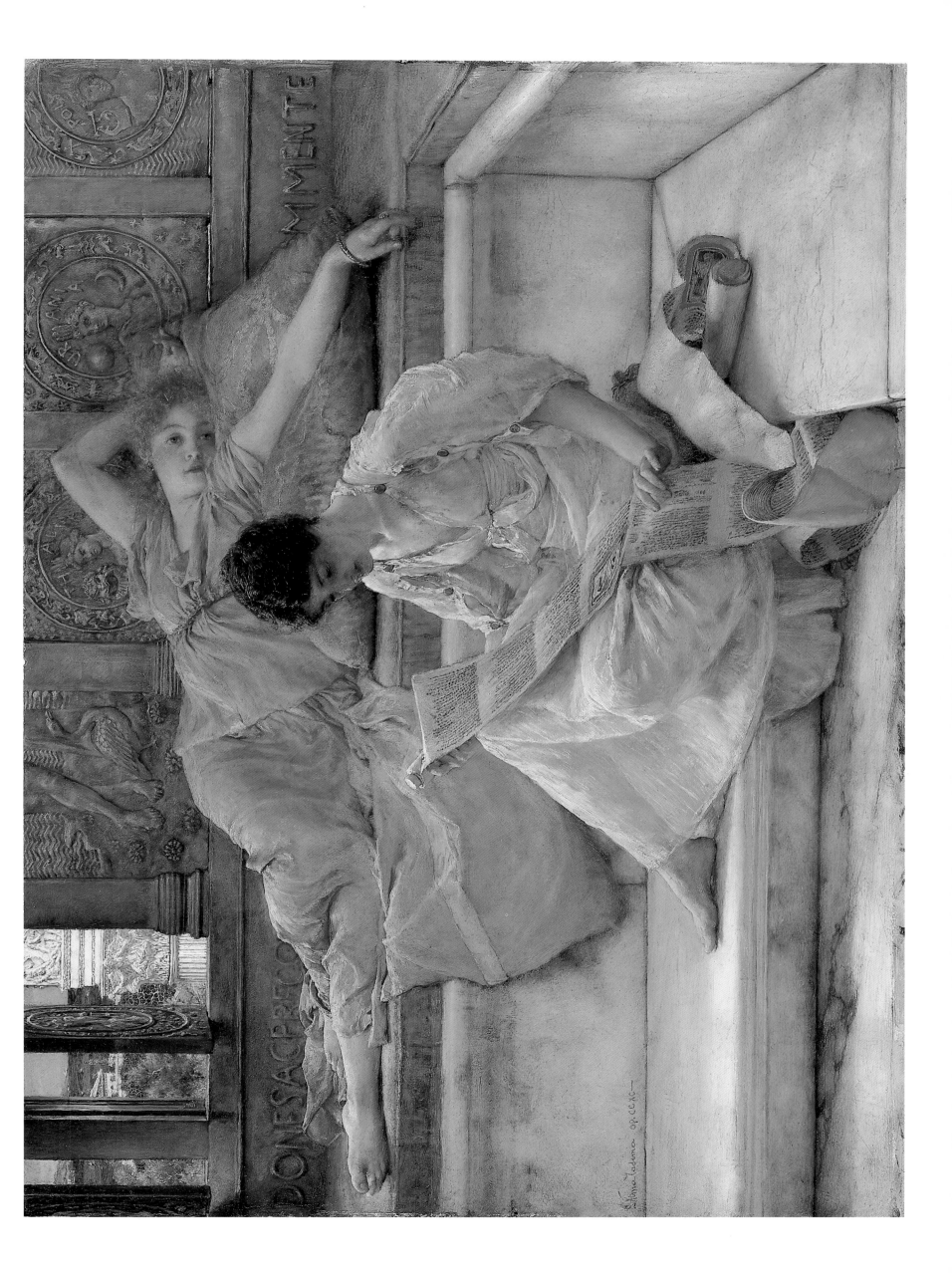

—— PLATE 20 ——

A DEDICATION TO BACCHUS

Opus CCXCIII, 1889
Oil on canvas, 30½ × 69¾ in/77.5 × 177.2 cm
Hamburger Kunsthalle

This is the first and larger of two versions of this painting. Its
wealth of archaeological detail was so much discussed
that it became the subject of a bestselling pamphlet by
Frederick Stephens. The work focuses on a child
who, accompanied by her mother and family, is about to be
dedicated to Bacchus, the god of wine. A Dionysiac
procession bearing wine approaches an altar, behind which is
the statue known as the 'Younger Furietti Centaur',
now in the Capitoline Museum, Rome. Behind the altar there
is a relief adapted from the *centauromachy* frieze
(depicting the legendary battle between Lapiths and centaurs)
which comes from the Temple of Apollo at Bassae and is
now in the British Museum. On the far left stands a priestess
with the silver *krater* from the Hildesheim Treasure,
previously seen in such pictures as *The Women of Amphissa*.

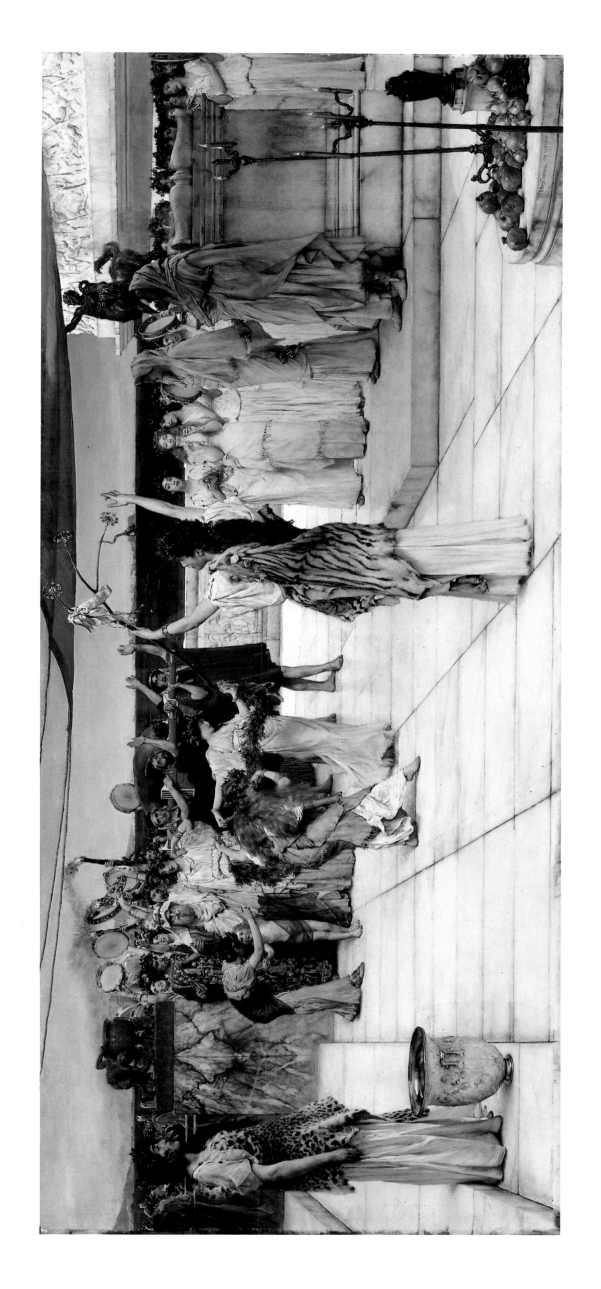

——— PLATE 21 ———

The Frigidarium

Opus CCCII, 1890
Oil on panel, 17¾ × 23½ in/45.1 × 59.7 cm
Private collection

'The composition is exceptionally complex, difficult
and successful,' wrote the art critic of the
Athenaeum, who was permitted to see the painting
while work was in progress. When it was
shown at the Royal Academy several months later,
Alma-Tadema had altered it yet again. Like
his other scenes of Roman baths, such as *An
Apodyterium*, which shows a changing room, it
provided a respectably academic excuse, replete
with such archaeological reconstructions as
the niches in the wall for clothes and valuables, for a
voyeuristic sortie into a world normally barred
to Victorian men. *The Frigidarium* was painted as a
commission for Sir Max Waechter, High
Sheriff of Surrey, as a companion to *A Kiss*.

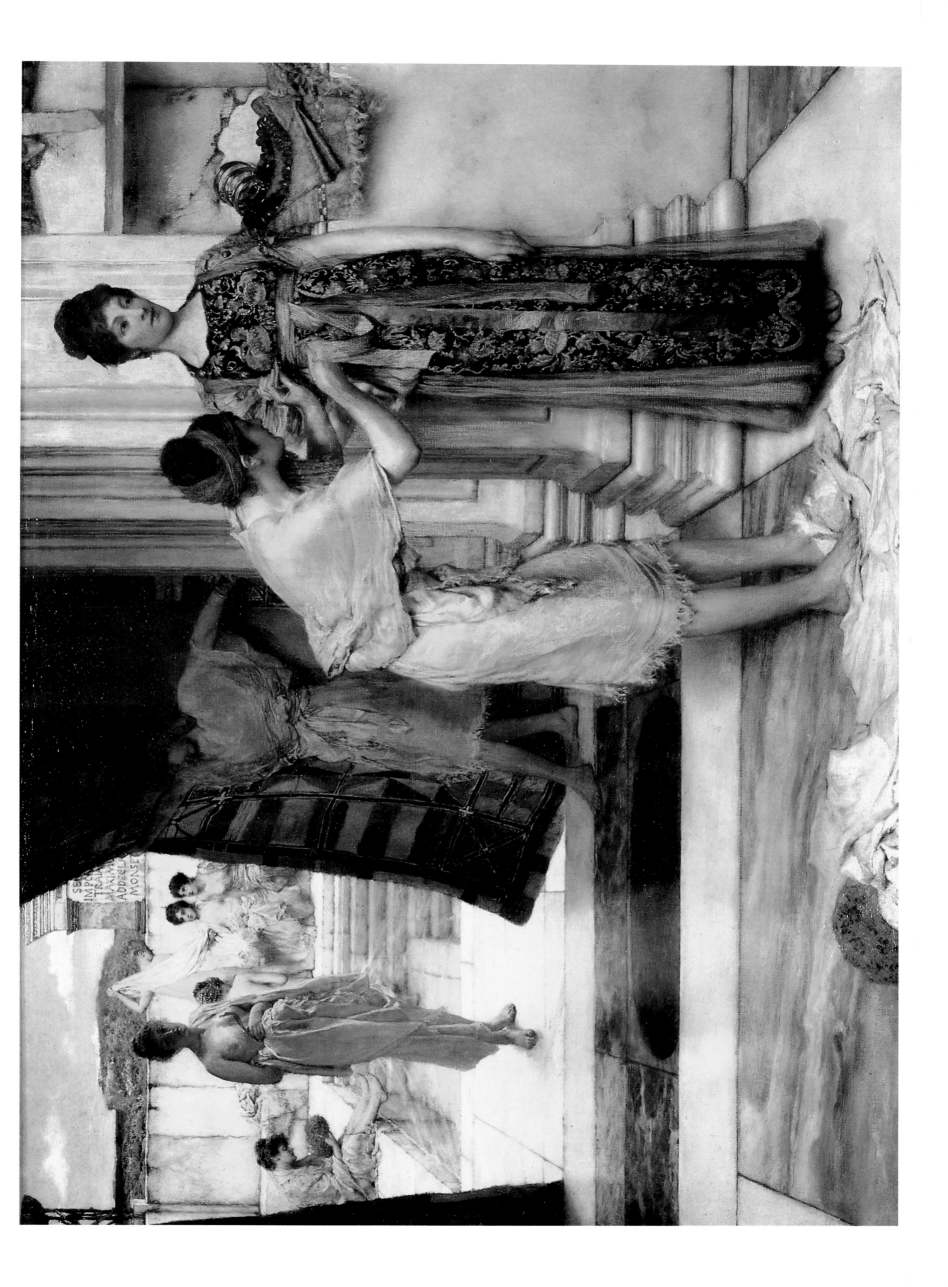

———— PLATE 22 ————

PROMISE OF SPRING

Opus CCCIII, 1890
Oil on panel, 15 × 8⅞ in/38 × 22.5 cm
Bequest of Frances M. Baker
Courtesy, Museum of Fine Arts, Boston

This small picture features Alma-Tadema's stock-in-trade of
a courting couple, blossom and marble. Like many of
his later paintings its title, *Promise of Spring*, is deliberately
enigmatic – who is promising what to whom, or is it
the hopefulness of the new season and of the lovers' vows to
each other that are suggested? Such paintings thereby
became conversation-pieces, inviting the viewer to speculate
on its meaning and that of the subject. Also in common
with much of his late work, it has some of the qualities of a
snapshot, as if the woman is looking directly into the
camera's lens. It is known that Alma-Tadema was a devotee
of photography which he used to full effect in compiling
his voluminous reference albums. The Kodak camera had
been invented just two years earlier, and Alma-Tadema,
fascinated by mechanical gadgets, was one of George
Eastman's earliest customers.

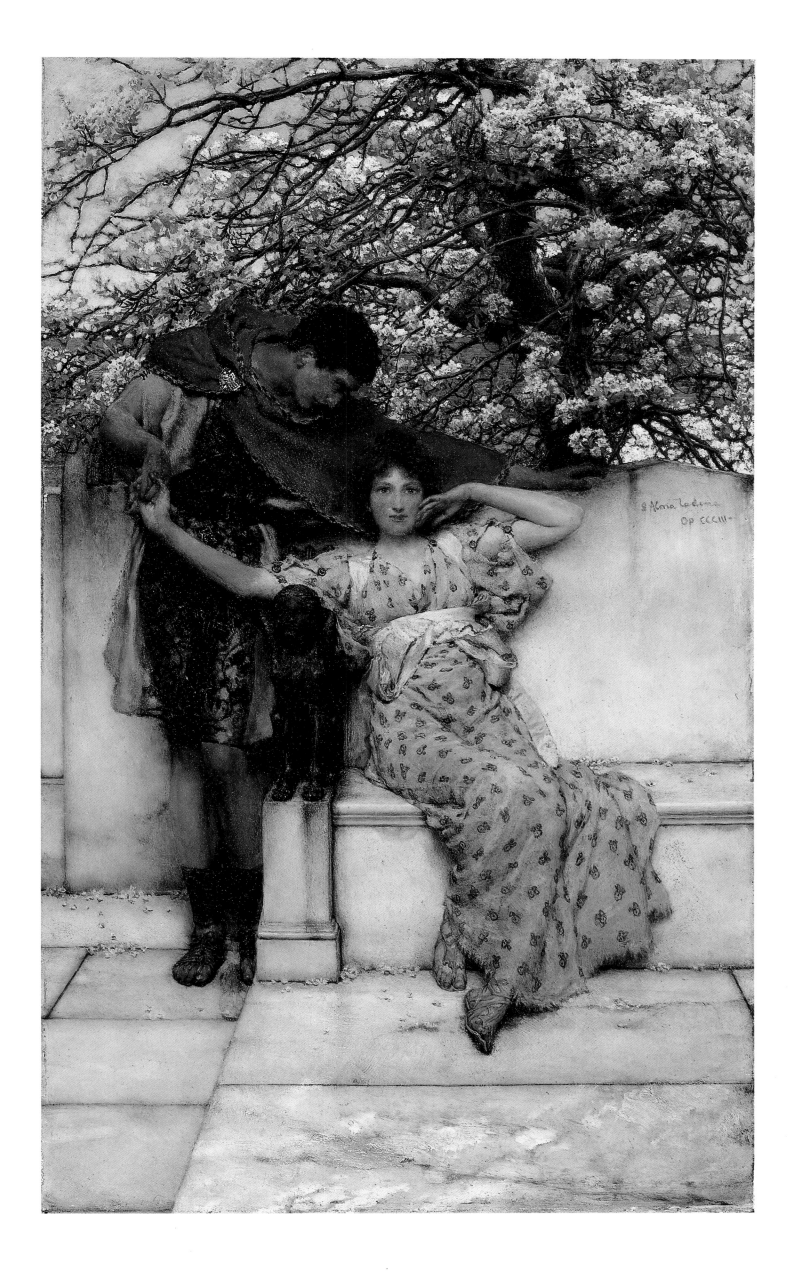

———— PLATE 23 ————

An Earthly Paradise

Opus CCCVII, 1891
Oil on canvas, 34 × 65 in/86.4 × 165.1 cm
Private collection

At the time of its first showing at the Royal Academy, the
Athenaeum described *An Earthly Paradise* as 'A subtle and
refined exercise in blue and its allies . . . tints which,
severally, are most tender and delicate, and, as a
whole, combined charmingly in every respect.' Inspired by a
quotation from Algernon Swinburne, 'All the Heaven
of Heavens in one little child', the sentimentality of the
mother-and-child theme appealed to Victorian taste
and featured frequently in Alma-Tadema's work, both in
superficially 'Roman' subjects such as this and in more
conventional portraits. The Mexican onyx window seen in
the right background was one of the exotic details to
be found in Alma-Tadema's studio.

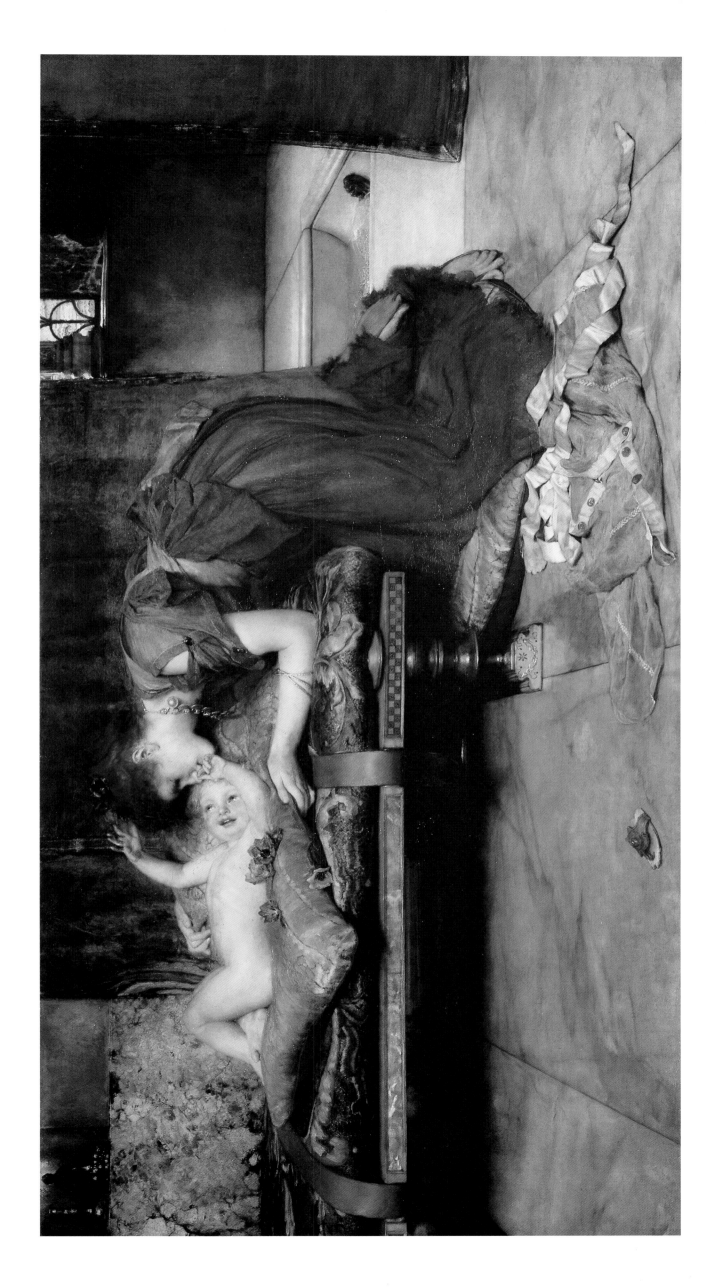

———— PLATE 24 ————

A Kiss

Opus CCCXII, 1891
Oil on panel, 18 × 24¼ in/45.7 × 62.9 cm
Private collection

Commissioned as a companion to *An Apodyterium*, *A Kiss* was
painted beside the Starnberger See near Munich
where Tadema visited Georg Ebers. We are spectators on a
Roman terrace overlooking a lake in which several
women are bathing, with a broad panoramic vista behind. A
woman carrying a towel and a triple hook from which
toilet articles were suspended ascends the stairs with a child,
who is kissed by a girl. Incidental antiquarian interest
is provided by the tripod and bas-relief and lettering so
distorted by the perspective as to be illegible. This
skilful combination of sentiment and archaeology, with a hint
of the risqué provided by the solitary nude bather,
was shown at the Royal Academy in 1891 and was one of the
213 works shown at the Alma-Tadema Memorial
Exhibition at the Royal Academy the year after his death.

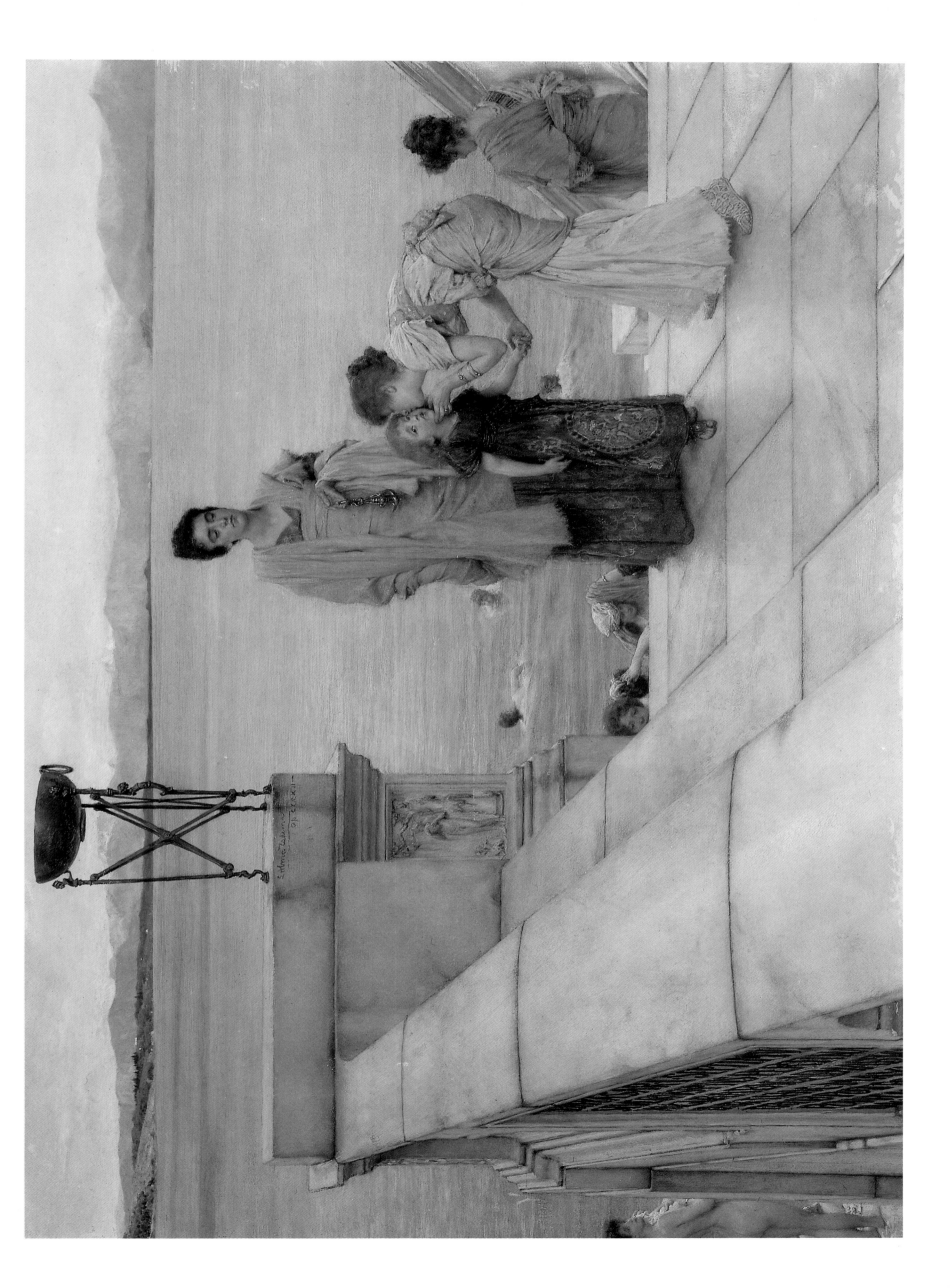

——— PLATE 25 ———

Comparisons

Opus CCCXVI, 1892
Oil on canvas, 18 × 24 in/45.7 × 61 cm
Cincinnati Art Museum
Gift of Emile L. Heine in memory of Mr and Mrs John Hauck

In *Comparisons* Alma-Tadema revisits the composition of his popular painting, *The Favourite Poet*, which similarly features two elegant women in rich costume, one of whom is reading. In this instance her book is a codex that is bound in a recognisable cover, the late 4th century AD Roman ivory Symmachi leaf of the Nicomachi and Symmachi Diptych, which Alma-Tadema would have seen in the Victoria & Albert Museum collection. His studio sofa is once again in evidence, its delicate moulding contrasting with the impressive solidity of the table's griffin supports. They are reminders of the advice given by Alma-Tadema's teacher, Baron Leys, who urged his pupil to paint convincingly, demanding the sort of table that "everyone knocks his knees to pieces on!"

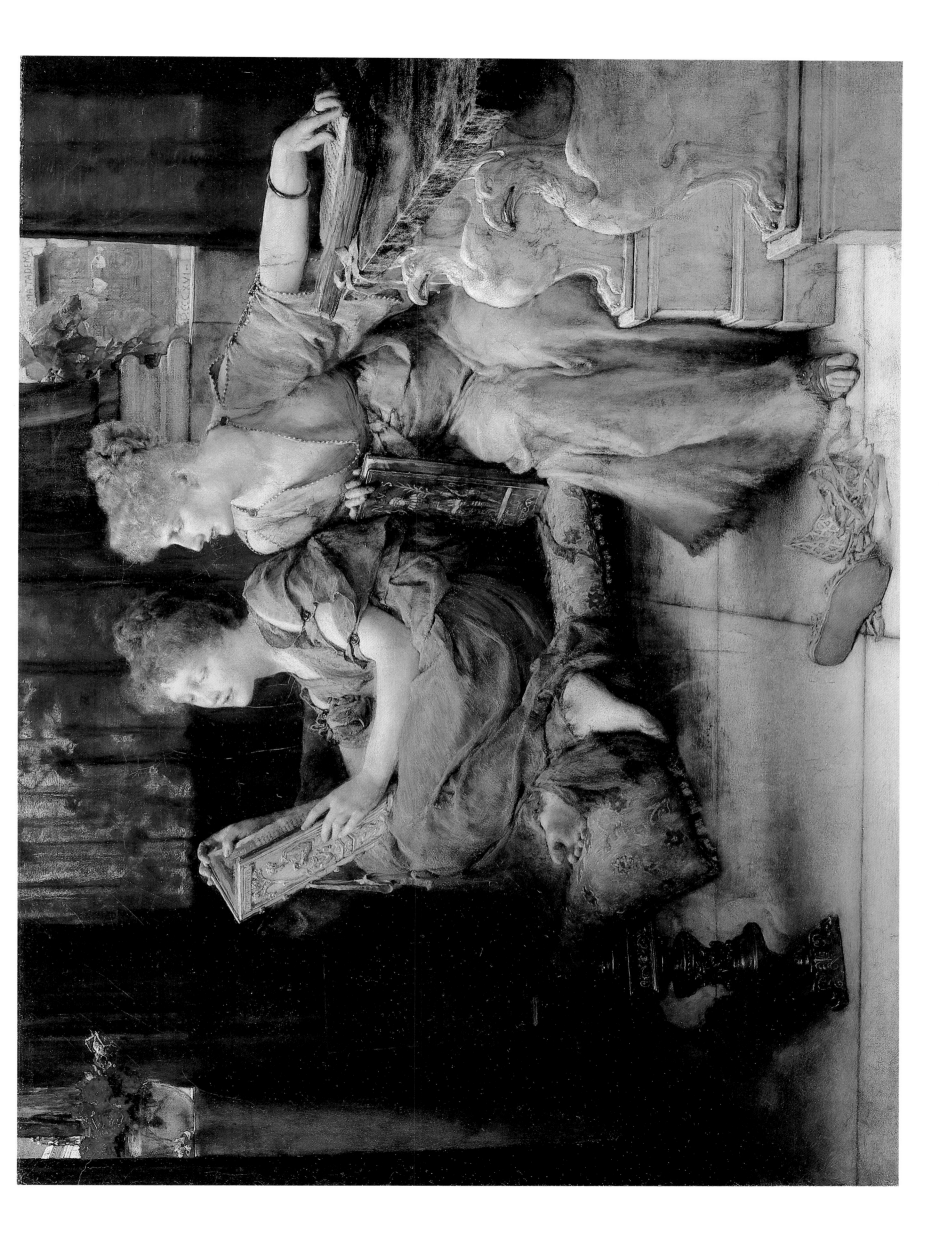

——— PLATE 26 ———

UNCONSCIOUS RIVALS

Opus CCCXXI, 1893
Oil on canvas, 18 × 25 in/45.7 × 63.5 cm
City of Bristol Museum and Art Gallery

Two Roman women pose beneath an impressive atrium,
apparently unaware, as the title suggests, that they
represent two points in a lover's triangle. The putto on the
pillar playing with a tragic mask is taken from one in
the Capitoline Museum, Rome. On the right, there is the
lower part of a seated figure of Dionysos, while
decorative relief of erotes and swags ornamented with
dramatic masks perhaps symbolize both the drama
and pleasures of courtship. The models indicate the two
types of women most frequently encountered in
Alma-Tadema's paintings – the dark Mediterranean,
appropriately derived from the Greek and Italian models
who flocked to London in the late nineteenth century, and
the red-haired *femme fatale* much favoured by the
Pre-Raphaelites and their followers. Alma-Tadema's models
were seldom beautiful according to classical ideals,
but their 'girl-next-door' quality further emphasized that he
was presenting scenes of everyday life, his Romans
indistinguishable from Victorians.

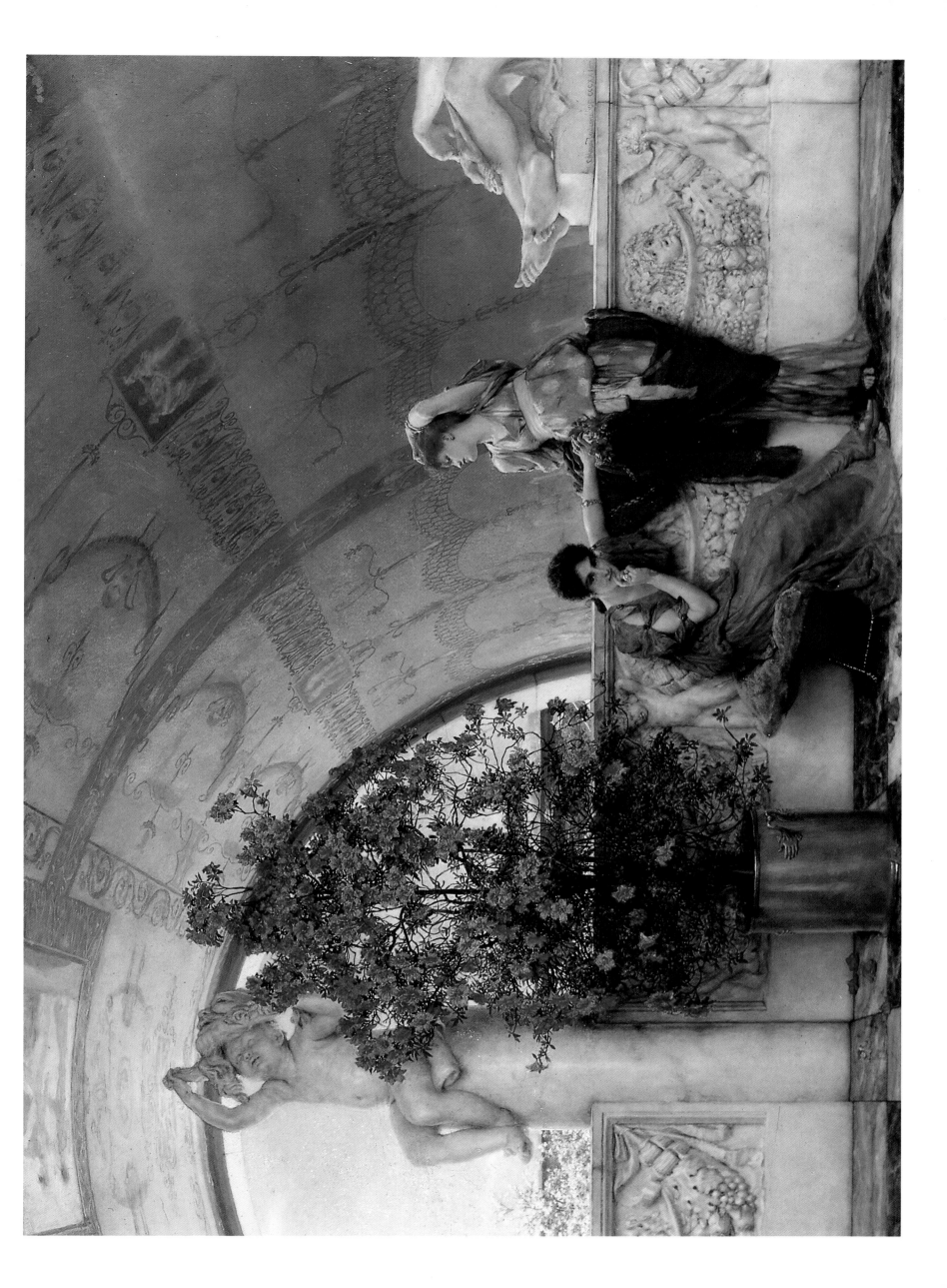

—— PLATE 27 ——

GOD SPEED!

Opus CCCXXII, 1893
Oil on panel, 10 × 5 in/25.4 × 12.7 cm
Reproduced by Gracious Permission of Her Majesty the Queen

In paintings such as *A Coign of Vantage*, *The Coliseum*, *At Aphrodite's Cradle* and this work, Alma-Tadema adopted an unusual perspective, looking down upon a group of people who are in turn looking down on others – in this instance some departing traveller. We do not actually see who this is, but are led to assume by the woman's enthusiastic gesture as she scatters flowers that he is her beloved. The triumphal arch is based on that at Benevento, to the north-east of Naples, erected in AD 114 in honour of the Emperor Trajan. *God Speed!* was one of several paintings that were acquired by the Prince of Wales, later King Edward VII, who was a frequent visitor to Alma-Tadema's house.

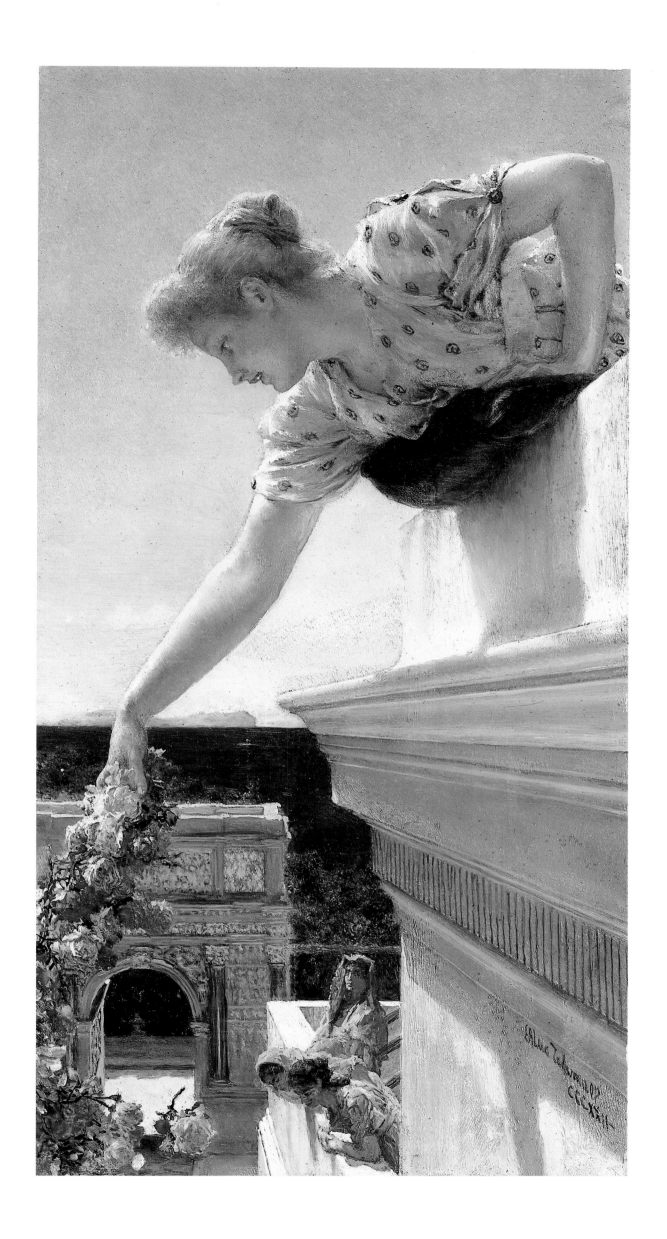

———— PLATE 28 ————

SPRING

Opus CCCXXVI, 1894
Oil on canvas, 70½ × 31½ in/179.1 × 80 cm
The J. Paul Getty Museum, Malibu

The procession is of servants of the Temple of Flora who are
celebrating the Roman festival of Cerealia. A verse
from Algernon Swinburne's poem, *Dedication*, appeared on
the original frame:

In a land of clear colours and stories,
In a region of shadowless hours,
Where earth has a garment of glories
And a murmur of musical flowers.

The setting is imaginary, bringing together architectural
details from a multiplicity of sources, including
wall-paintings from Pompeii in the roundels on the banner,
the *centauromachy* frieze from the Temple at Bassae
recycled from *A Dedication to Bacchus* on the building on the
left and a votive plaque beginning with the phrase,
Hunc Lucum Tibi Dedico – 'I dedicate this wood to you'.
Carried in the procession are two silver satyr herms,
each with an infant Dionysos on his shoulder and carrying a
liknon, or winnowing basket filled with fruit. One of
Alma-Tadema's most famous and popular works, it took him
four years to complete the extraordinary detail of its
impressive composition, during which time it was repeatedly
reworked in his quest to combine aesthetic perfection
and historical accuracy. The innumerable figures were
constantly erased or added, and the final tableau
features members of his family, friends and fellow artists,
such as the musicians Sir George and Lillian Henschel
and their daughter Helen who looks down from the balcony
on the right.

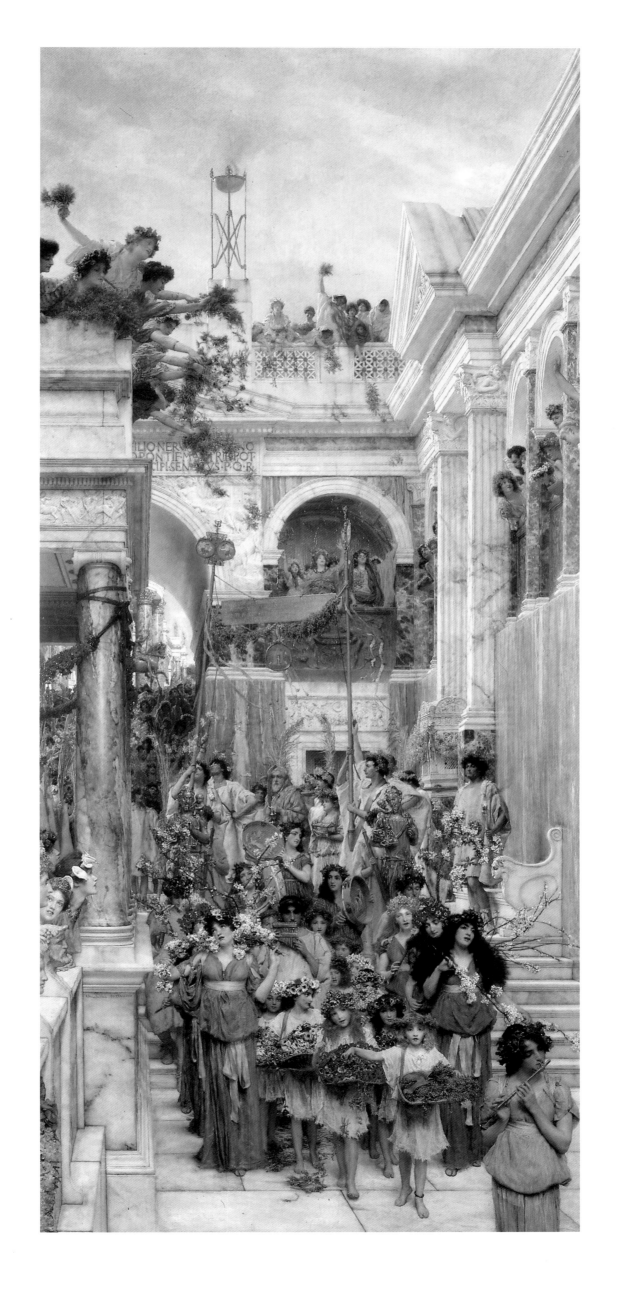

——— PLATE 29 ———

A COIGN OF VANTAGE

Opus CCCXXXIII, 1895
Oil on panel, 25⅞₁₆ × 17½ in/64 × 44.5 cm
Private collection

A coign is literally a cornerstone, and the phrase 'a
coign of vantage' is a quotation from Shakespeare's
Macbeth. Alma-Tadema's unusual use of vertiginous
perspective had already featured in such works
as *God Speed!* and was later employed to great effect
in *The Coliseum* and *At Aphrodite's Cradle*, but
A Coign of Vantage was perhaps his most successful
excursion into this technically challenging
composition. Three elegantly draped women watch
the Roman fleet's arrival in a remarkable work
that combines a dizzying viewpoint and the contrast
of the sumptuous blue of the Mediterranean
and dazzling white marble (which in part has
regrettably suffered from heavy-handed restoration).

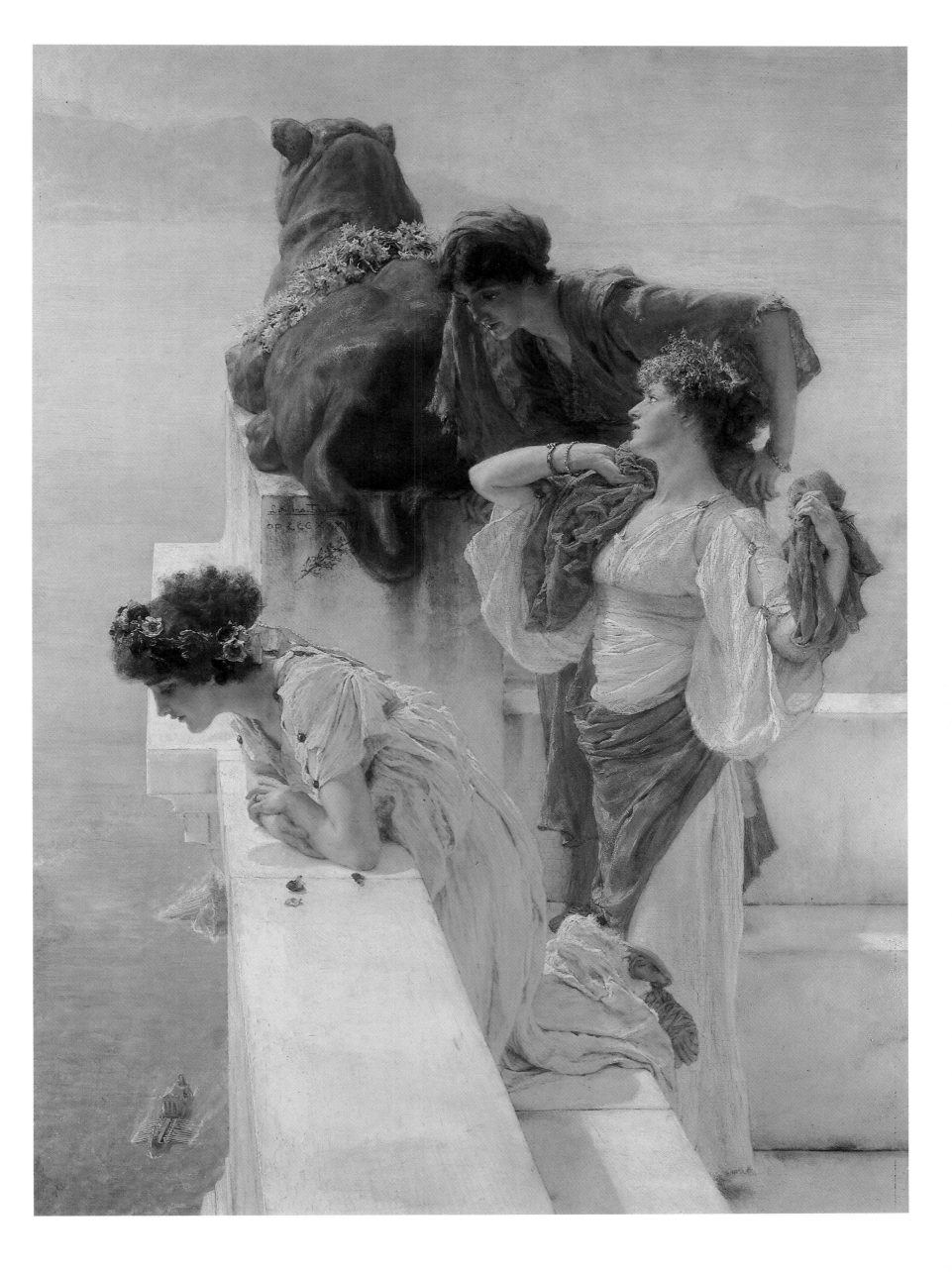

—— PLATE 30 ——

A Difference of Opinion

Opus CCCXXXIX, 1896
Oil on panel, 15 × 9 in/38.1 × 22.9 cm
Private collection

In this almost shimmeringly bright painting, Alma-Tadema
returns to a favourite theme of two lovers posed
beside a fountain or laver, like an oasis in the heat, where
they air their feelings – in this instance conflictingly,
or so the title tells us. The archaeological elements include,
on the laver, a bronze figure of a boy with a goose,
based on one found in Pompeii, and in the background a
relief showing a satyr with Pan pipes at a rustic shrine
·topped by a herm, with Alma-Tadema's signature
incorporated in the masonry and a sundial above. His
contrasting types of model, the swarthy Mediterranean male
and winsome 'English rose' are again in evidence.

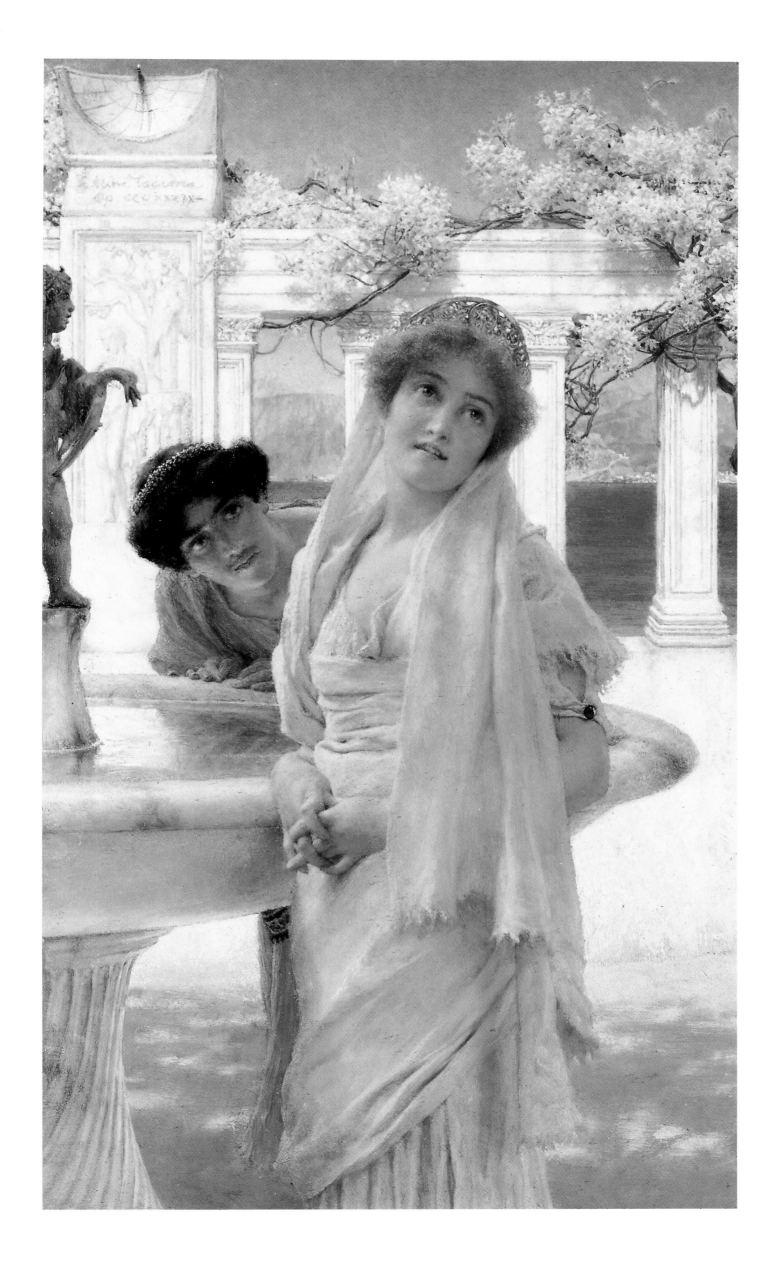

——— PLATE 31 ———

THE BATHS OF CARACALLA

Opus CCCLVI, 1899
Oil on canvas, 60 × 37½ in/152.4 × 95.3 cm
Private collection

For his most spectacular Roman baths painting, Alma-Tadema
chose the Baths of Caracalla, their ruins famed as the
location where Shelley wrote *Prometheus Unbound*. Dedicated
in AD 212, they were of gigantic dimensions with three
bathing halls capable of accommodating 1,600 bathers. He
studied reports of the latest archaeological excavations,
embellishing the scene with a marble ship in the centre of
the baths, which he probably based on a Renaissance
copy of a model found in Rome. The result, according to the
Art Journal, was that 'Mr Alma-Tadema has once more
built up a fascinating picture of Roman life, wonderful in its
classical faithfulness and truth to archaeological detail.
He has restored on canvas the famous bath of Caracalla.' The
Emperor Caracalla himself enters in the background
in a vignette that was destined to become the subject of
another painting, *Caracalla*. First shown at the Royal
Academy in 1899, the year of Alma-Tadema's knighthood,
The Baths of Caracalla was bought by an American
collector, one of many who ensured that his work is as well
represented in the United States as in Europe.

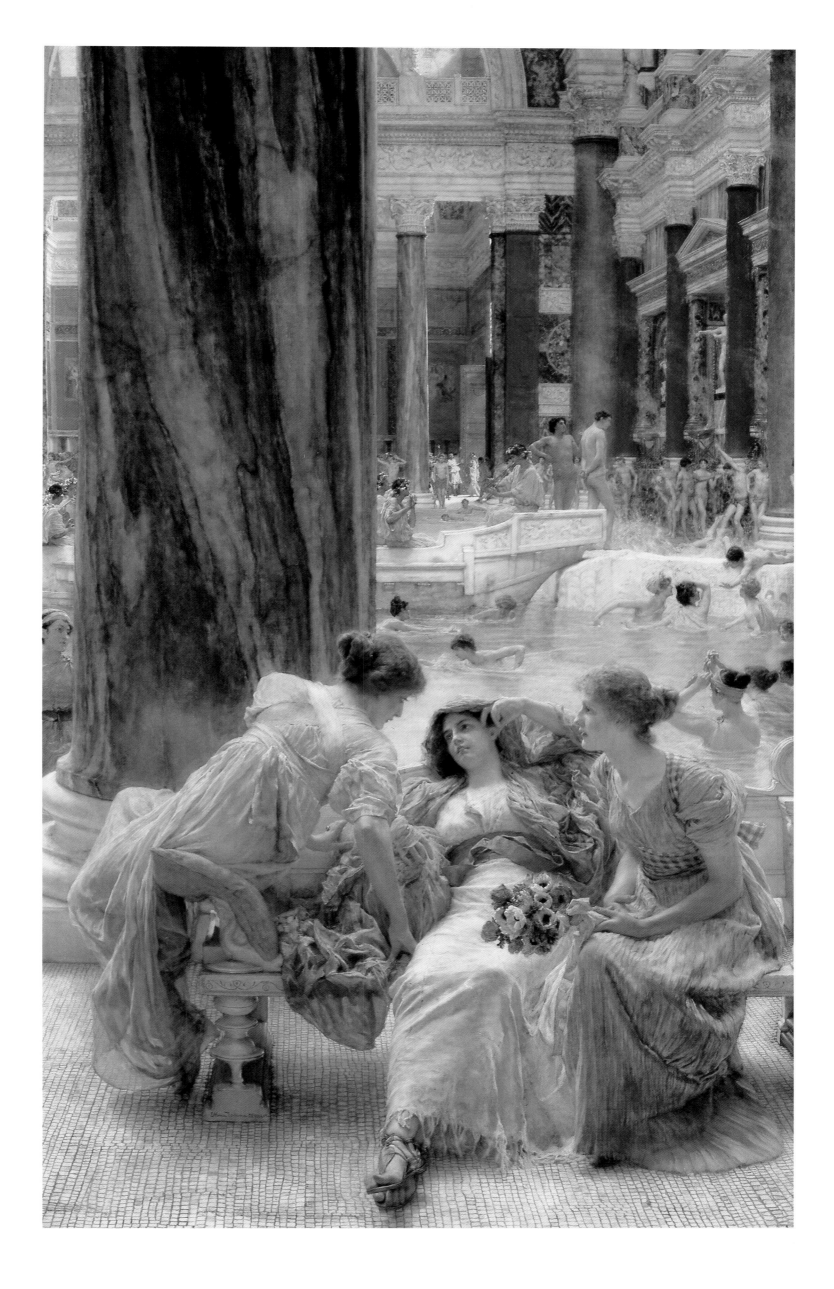

——— PLATE 32 ———

VAIN COURTSHIP

Opus CCCLXII, 1900
Oil on canvas, 30½ × 16¼ in/77.5 × 41.3 cm
Private collection

By this stage in Alma-Tadema's career, the
archaeological basis of his paintings was often
relegated as the anecdotal or sentimental elements
took precedence (though, as some of his last
paintings were to prove, he retained his mastery of
the genre to the end). *Vain Courtship* was clearly
painted in his studio, with their walls of 'sea-green
marble', a silver vase of hollyhocks and his
much-painted studio sofa appearing in duplicate,
only the couple's costumes indicating that we are
not witnessing a tryst during one of the artist's
famous 'At Homes'.

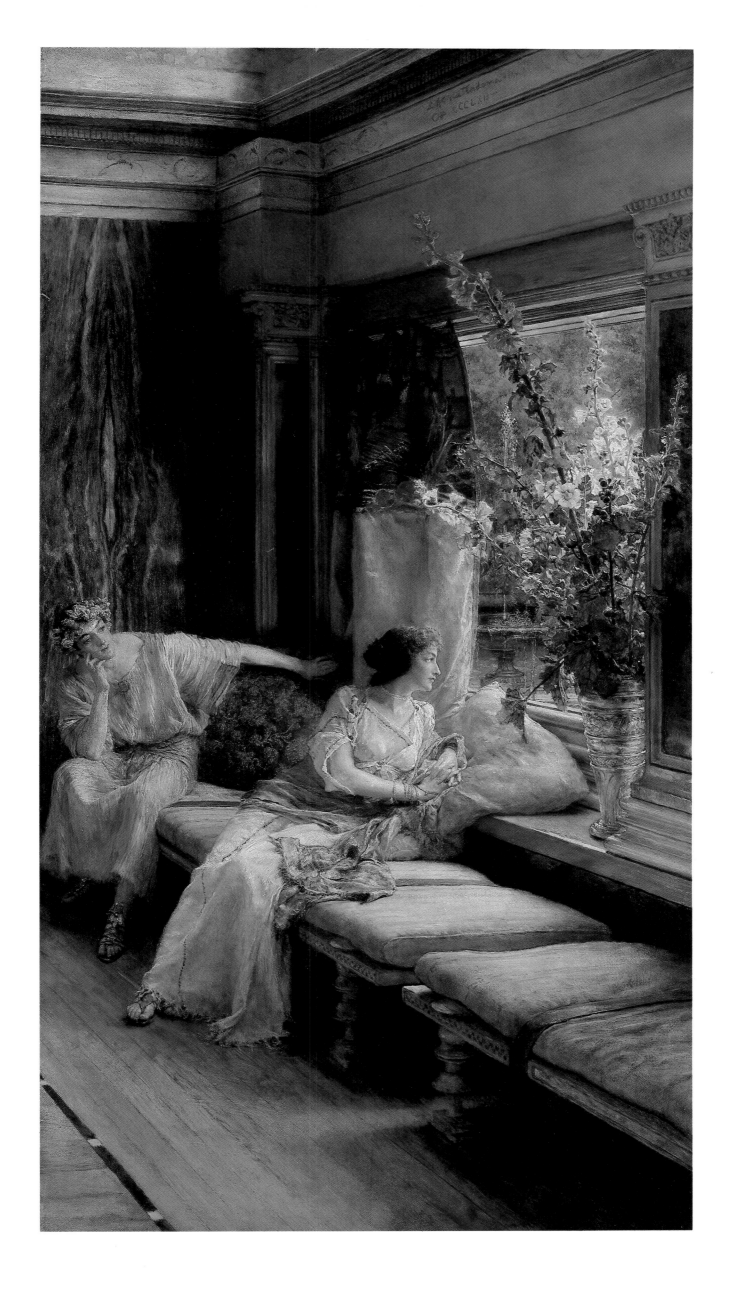

—— PLATE 33 ——

UNDER THE ROOF OF BLUE IONIAN WEATHER

Opus CCCLXIII, 1901
Oil on panel, 21¾ × 47½ in/55.3 × 120.7 cm
Private collection

One of Alma-Tadema's finest paintings of sunny indolence,
its title appears to derive from a line in a letter from
Shelley to Maria Gisborne, written in 1820: 'We watched the
ocean and sky together, under the roof of blue Italian
weather.' When the picture was exhibited at the Royal
Academy in 1901, the *Art Journal* noted: 'Under the
Roof of Blue Ionian Weather is concerned with lightly
draped, garlanded figures grouped about a semi-circular
tiered lounge, each vein of whose white marble, whether in
scintillating light or reposeful shadow, is scrupulously
rendered.' The painting took over two years, on and off, to
complete, but certain elements were based on other
works: the woman in the foreground and the man beside her,
for example, had appeared previously in a very similar
composition in the 1899 watercolour, *Attracted*, which is in
the Royal Collection.

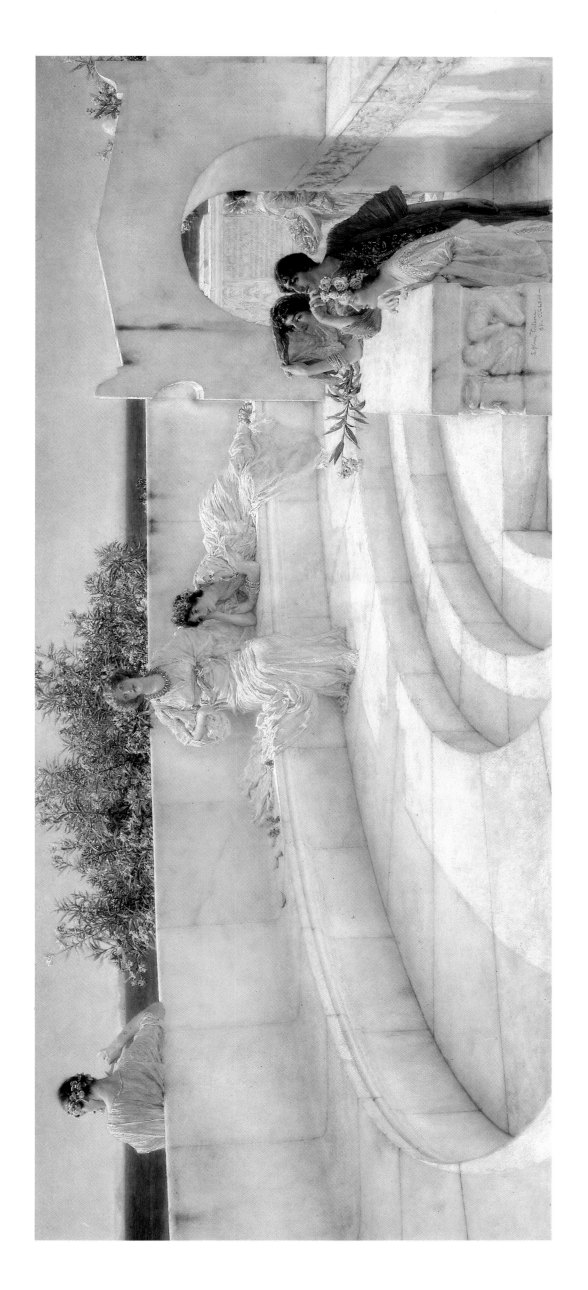

———— PLATE 34 ————

SILVER FAVOURITES

Opus CCCLXXIII, 1903
Oil on panel, 27¼ × 16⅝ in/69.2 × 42.2 cm
Manchester City Art Galleries

The 'silver favourites' of the title are the carp in the pond
that one of the girls is feeding, using her tympanum as
a makeshift receptacle. To emphasize the piscatorial
reference, the frame bears the lines from Wordsworth:

Where, sensitive of every ray,
That smites this tiny sea,
Your scaly panoplies repay
The loan with usury.

The sky, brightening toward the horizon, the sea and marble
bench are represented as three serried and contrasting
bands that create an illusion of breadth that is remarkable in
so vertical a painting. The composition evidently posed
difficult problems which Alma-Tadema was still struggling to
resolve up to the date by which he had promised the
painting to its purchaser. He was forced to write to apologize
for having been '. . . unable to master all the difficulties
in the picture. . . I would have been much more ashamed of
myself if I would have let the picture go without being
thoroughly satisfied. Give me one more day for by tomorrow
night I trust your messenger will not come in vain.'

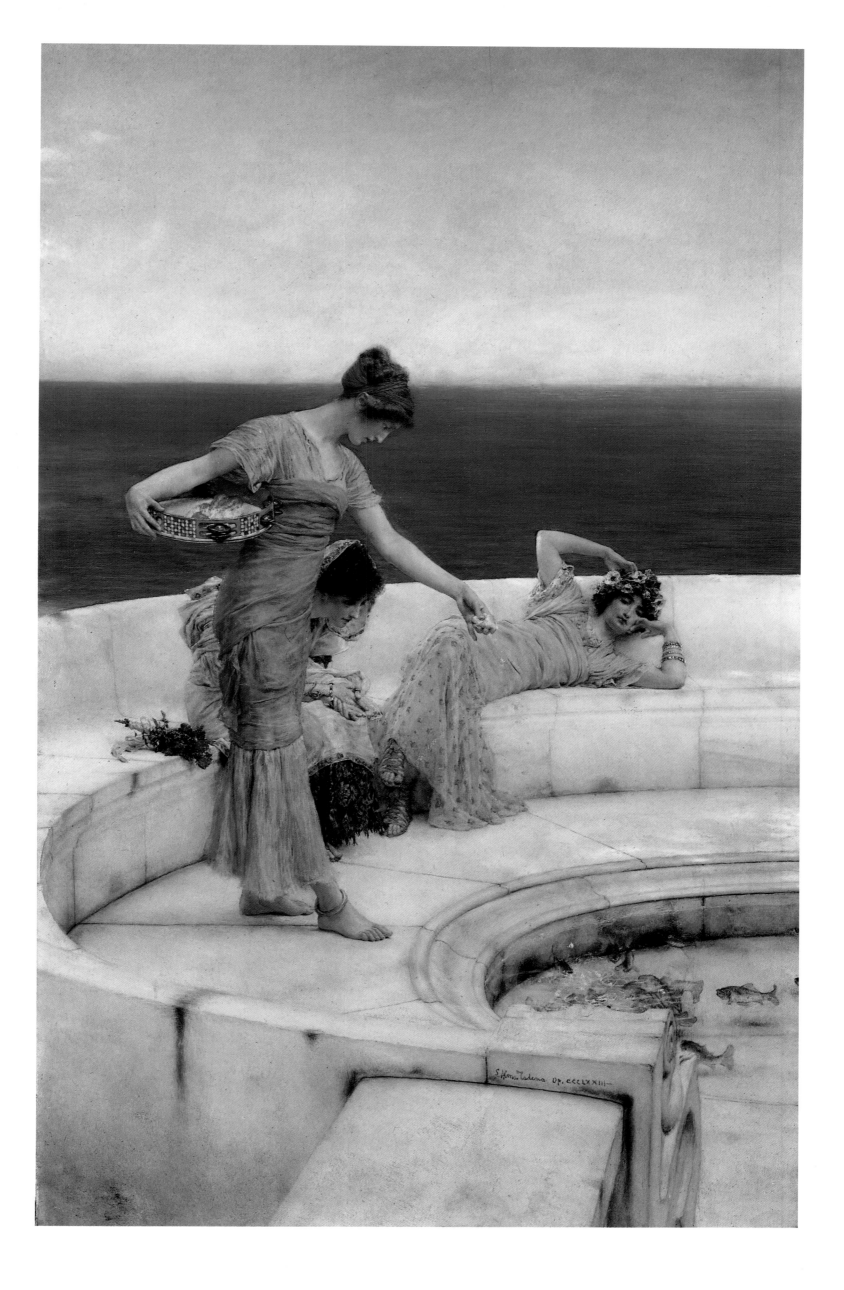

——— PLATE 35 ———

THE FINDING OF MOSES

Opus CCCLXXVII, 1904
Oil on canvas, 54⅛ × 84 in/137.5 × 213.4 cm
Private collection

Commissioned in 1902 by the engineer Sir John Aird (who
paid £5,250 for the painting), it commemorates Aird's
work on the Nile, where his company built the Aswan Dam –
the opening of which Alma-Tadema attended in the
company of Winston Churchill and other dignitaries. The
task of executing this for him unusually large painting
preoccupied him for so long that Lady Laura Alma-Tadema
joked that Moses was now 'two years old, and need no
longer be carried': It was the only painting he completed in
1904. Despite its title, Alma-Tadema has chosen to
show the scene immediately after the finding of Moses as he
is carried in his basket to Pharaoh's palace. On the
far bank there is a throng of slaves with the Pyramids behind.
The identical tables and vases are based on objects in
the British Museum. As well as replicas of such items,
Alma-Tadema's reference scrapbooks of prints,
photographs and sketches included numerous Egyptian
motifs such as the hieroglyphs seen here representing,
on the statue base on the left, 'Beloved of Ra, King of Upper
and Lower Egypt' and, on the seat, 'Life' and 'Dominion'.

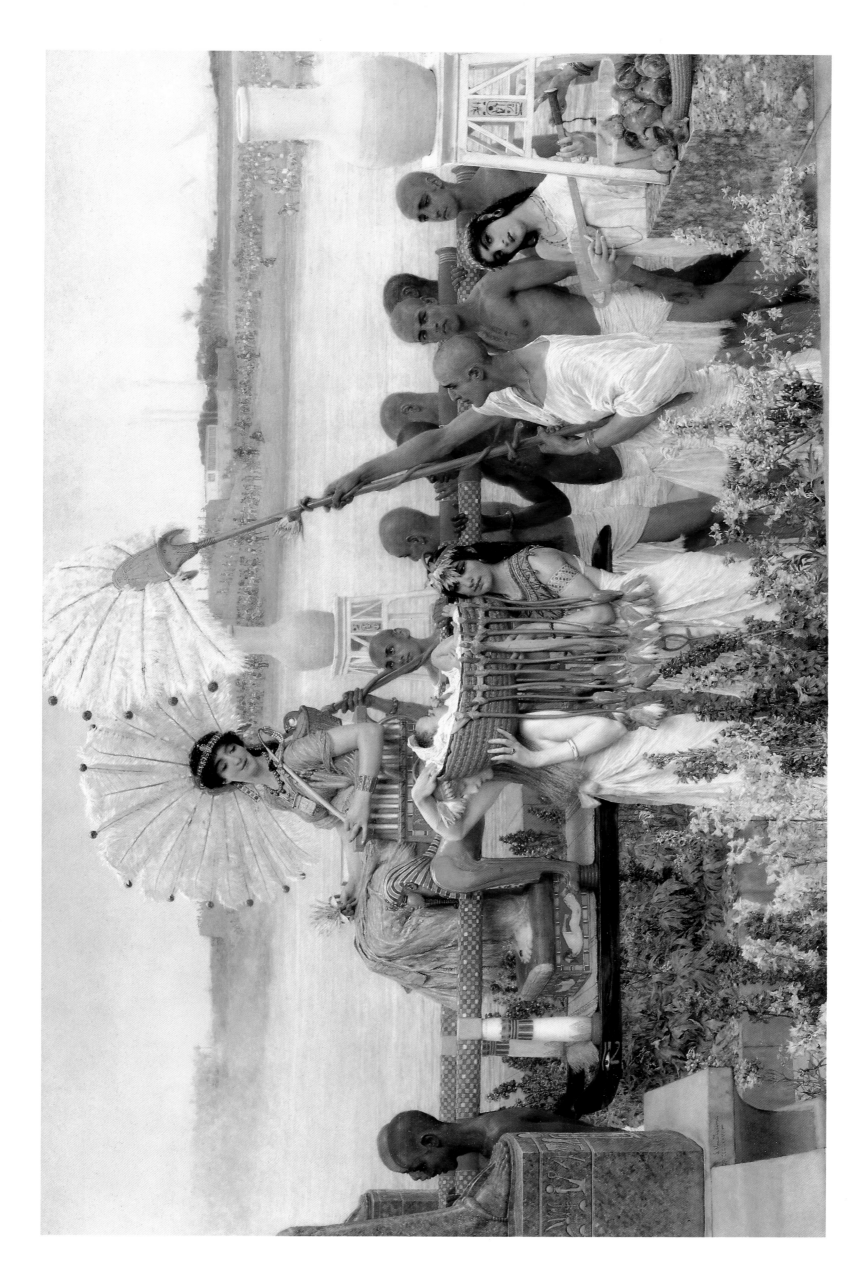

———— PLATE 36 ————

A World of their Own

Opus CCCLXXVIII, 1905
Oil on panel, 5⅛ × 19¾ in/13 × 50.2 cm
Bequest of Mr and Mrs Charles Phelps Taft; the Taft Museum,
Cincinnati, Ohio

Alma-Tadema's only painting of 1905 was this small
but delicate study on the eternal subject of
lovers engrossed with each other as they lie on a
flowery clifftop. It is an unusually wide-angle
composition in which the ivory-headed stick, the
cameo brooch and the couple's costumes are
the only clues that we are in the ancient world,
reiterating that their preoccupations were
essentially identical to those of the modern one, that
human nature is the one great constant.

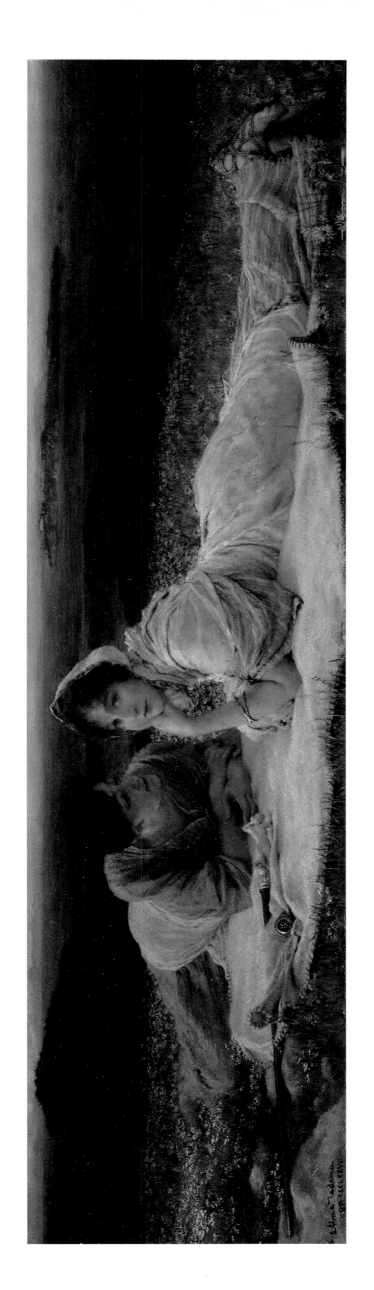

——— PLATE 37 ———

ASK ME NO MORE

Opus CCCLXXIX, 1906
Oil on canvas, 31½ × 45½ in/80 × 115.6 cm
Private collection

To Alma-Tadema's only painting of this year was appended a
quotation by Tennyson:

Ask me no more: thy fate and mine are seal'd;
I strove against the stream, and all in vain;
Let the great river take me to the main:
No more, dear love, for at a touch I yield.

The somewhat melodramatic gesture and title of this work
could open it to a charge of mawkish sentimentality,
but as with so many of Alma-Tadema's later works the
overriding response is one of admiration of his ability
to convey the viewer to a timeless sun-blessed land.

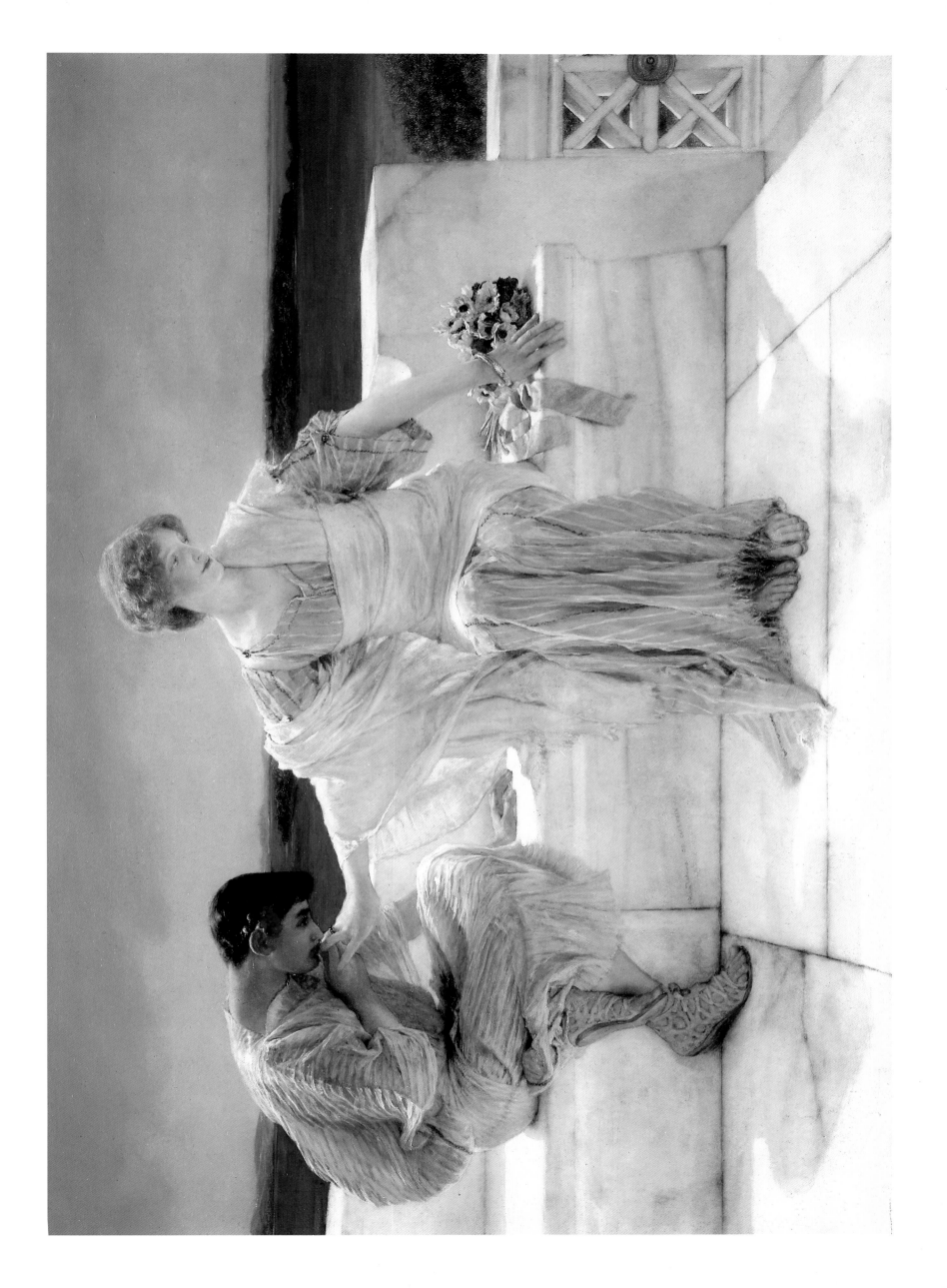

———— PLATE 38 ————

CARACALLA AND GETA

Opus CCCLXXXII, 1907
Oil on panel, 48½ × 60½ in/123.2 × 153.7 cm
Private collection

As if to demonstrate that, even though he was now over
seventy years old, he had lost none of his technical mastery,
Alma-Tadema embarked on one of the most complex
paintings he had ever undertaken. His last painting of a
specific historical event depicts the gala given in the Coliseum
in AD 203 by Septimus Severus on the occasion of his
bestowing the title of Antoninus Caesar on his son, Bassianus,
better known as Caracalla, who stands behind the
seated emperor, beside whom is his second wife, Julia Domna.
She is seen surreptitiously passing letters to an
attendant, presumably in connection with her aspiration to
gain similar honours for her son Geta (who was later
murdered by Caracalla), here shown standing between his
sisters. Geta's toga is emblazoned with gladiatorial
scenes that we partially see enacted below, where bear-baiters
are goading the animals with red cloths and avoiding
attack by pole-vaulting – a practice that Alma-Tadema based
on an ivory carving he had seen. He has spared no
labour in his attention to such archaeologically speculative
details as the inclusion of drinking fountains and altars,
while on the steps can be seen hirers of cushions, drink and
cake vendors, amid the 2,500 spectators he calculated
would be visible. The right-hand portion in which the
attendant stands, modified to show the scene before the
audience arrives, became the subject of his last finished
painting, *Preparations in the Coliseum*.

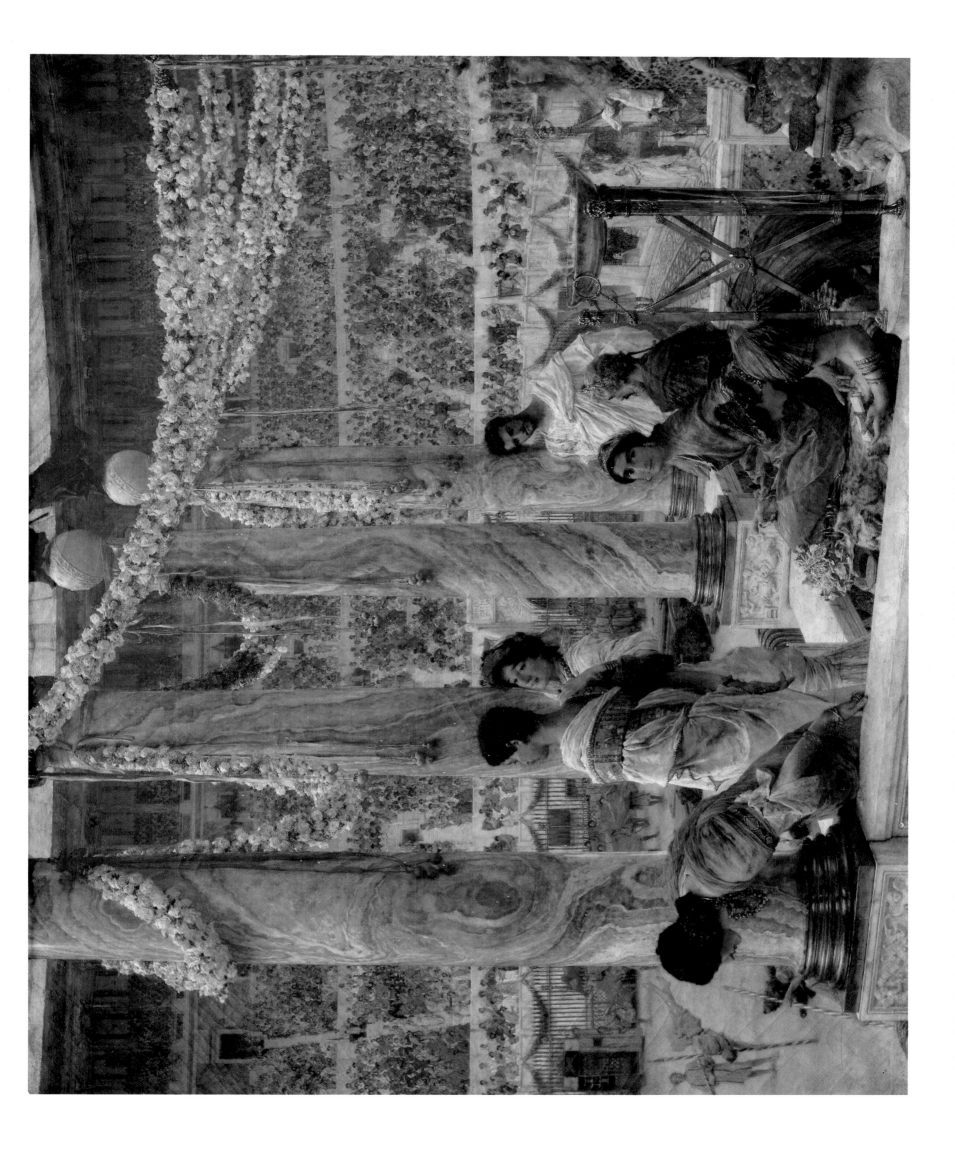

———— PLATE 39 ————

A Favourite Custom

Opus CCCXCI, 1909
Oil on panel, 26 × 17¾ in/66 × 45.1 cm
The Tate Gallery, London

In a recapitulation of some of his earlier paintings,
Alma-Tadema returned to the theme of
Roman baths, here locating the viewer beside the
water, with the changing room behind – a
direct reversal of the view seen in *The Frigidarium*.
Architecturally, *A Favourite Custom* is based
on Pompeian originals, the frieze above the door
being derived from one discovered in a
Pompeian bath and identified in a photograph in
Alma-Tadema's reference albums. On the left
we again find the silver *krater* from the Hildesheim
Treasure. A related drawing entitled *Splashing*
dates from the same year.

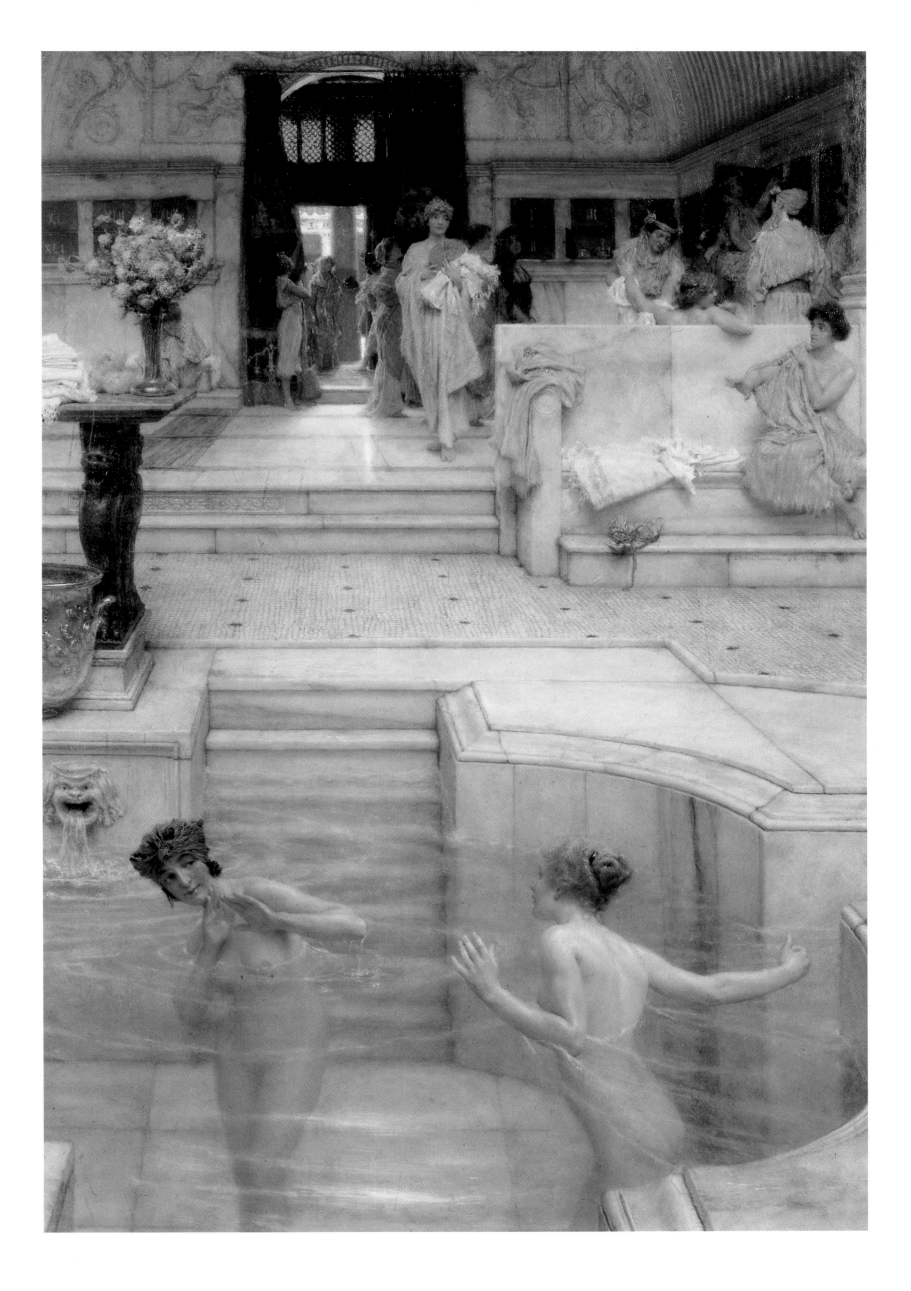

———— PLATE 40 ————

THE VOICE OF SPRING

Opus CCCXCVII, 1910
Oil on panel, 19⅛ × 45¼ in/48.6 × 114.9 cm
Private collection

This was one of Alma-Tadema's last important
works, and his sole oil painting of the year, his only
other output consisting of pencil drawings and
a watercolour address from the Royal Academy to
King George V to commemorate his accession.
In it, groups of people enjoy the coming of spring in
a flower-strewn coastal meadow, some gathering
garlands of flowers, others listening to a poet with a
lyre, while the central figure sits pensively.
The 'Cinemascope' panorama of such paintings and
the precision of Alma-Tadema's reconstructions
of Roman buildings and scenes of daily life and
Imperial drama were destined to become important
sources of reference for the coming generation
of Hollywood epic film-makers.

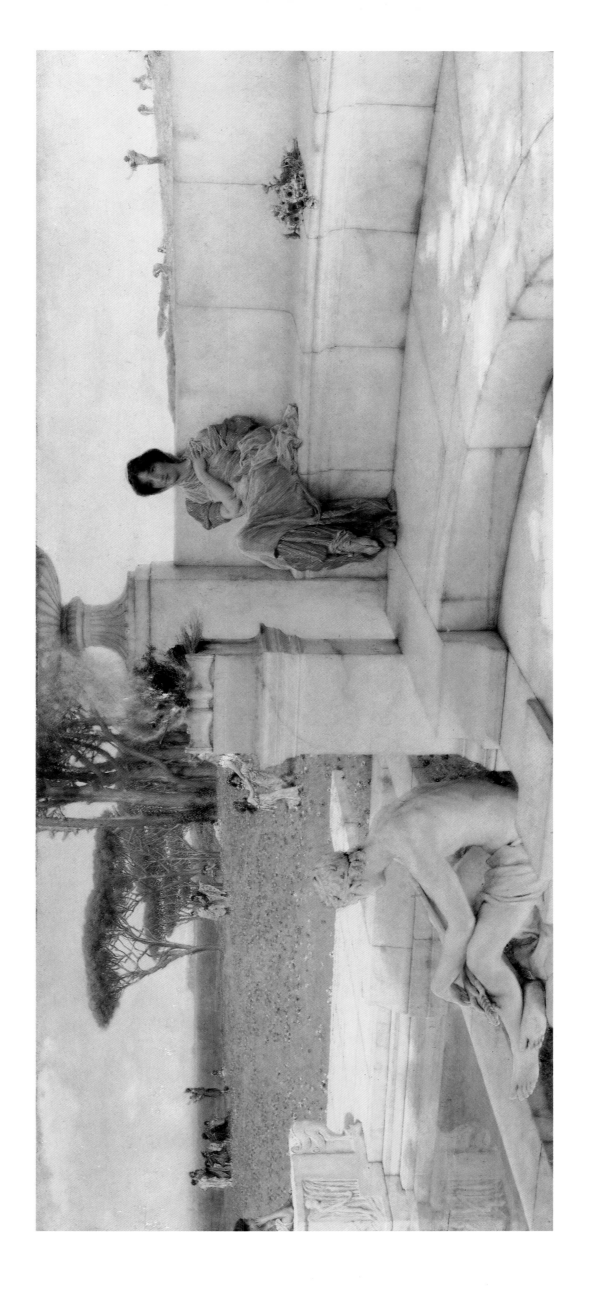

SELECT BIBLIOGRAPHY

Mario Amaya, 'The Painter Who Inspired Hollywood',
London: *The Sunday Times*, 18 February 1968

Mario Amaya, 'The Roman World of Alma-Tadema',
London: *Apollo*, December 1962

Russell Ash, *Alma-Tadema*, Aylesbury: Shire Publications, 1973

Russell Ash, 'The Sale of the Allen Funt Collection of
Paintings by Sir Lawrence Alma-Tadema', in *Art at Auction*,
London: Sotheby Parke Bernet Publications, 1974

Russell Ash, *et al*, *Sir Lawrence Alma-Tadema, OM, RA* [catalogue
of the auction of the Allen Funt Collection],
London: Sotheby's Belgravia, 1973

Rudolf Dircks, 'The Later Works of Sir Lawrence Alma-Tadema',
London: *Art Journal*, Christmas 1910

Georg Mark Ebers, *Lorenz Alma Tadema, his Life and Work*,
New York: W. S. Gottsberger, 1886

Christopher Forbes, *Victorians in Togas* [catalogue of the
Allen Funt Collection, exhibited at the Metropolitan Museum],
New York: Metropolitan Museum, 1973

Burton B. Fredericksen, *Alma-Tadema's 'Spring'*,
Malibu: J. Paul Getty Museum, 1979

William Gaunt, *Victorian Olympus*, London: Jonathan Cape, 1952

Edmund Gosse, *Lawrence Alma-Tadema, RA*,
London: Chapman & Hall, 1883

Edmund Gosse, 'Laurens Alma-Tadema', New York: *The
Century Magazine*, February 1894

Richard Jenkyns, *The Victorians and Ancient Greece*,
Oxford: Basil Blackwell, 1980

William Cosmo Monkhouse, 'Laurens Alma-Tadema, RA',
New York: *Scribner's Magazine*, December 1895

Royal Academy, *Exhibition of Works by the Late Sir Lawrence
Alma-Tadema, RA, OM*, London: Royal Academy, 1913

Sheffield City Art Galleries, *Sir Lawrence Alma-Tadema*,
Sheffield: Sheffield City Art Galleries, 1976

Percy Cross Standing, *Sir Lawrence Alma-Tadema, OM, RA*,
London: Cassell & Co., 1905

Frederick George Stephens, *Lawrence Alma-Tadema, RA*,
London: Berlin Photographic Co., 1895

Vern G. Swanson, *Sir Lawrence Alma-Tadema: The Victorian
Vision of the Ancient World*, London: Ash & Grant;
New York: Charles Scribner's Sons, 1977

Christopher Wood, *Olympian Dreamers: Victorian Classical
Painters, 1860–1914*, London: Constable, 1983

Helen Zimmern, 'The Life and Work of L. Alma-Tadema',
London: *Art Annual*, 1886

Helen Zimmern, *Sir Lawrence Alma-Tadema, RA*,
London: Bell & Sons, 1902

PAINTINGS IN PUBLIC COLLECTIONS

AUSTRALIA
Adelaide
Art Gallery of South Australia
Melbourne
National Gallery of Victoria
Sydney
Art Gallery of New South Wales

AUSTRIA
Vienna
Kunsthistorisches Museum

BELGIUM
Antwerp
Koninklijk Museum voor
Schone Kunsten

CANADA
Montreal, Quebec
Museum of Fine Arts
Sackville, New Brunswick
Owens Art Gallery, Mount
Allison University

FRANCE
Paris
Centre Georges Pompidou

GERMANY
Hamburg
Hamburger Kunsthalle

GREAT BRITAIN
Aberdeen
Aberdeen Art Gallery
Barnard Castle
Bowes Museum
Bedford
Cecil Higgins Art Gallery
Birkenhead
Williamson Art Gallery
Birmingham
Birmingham City Art Gallery
Brighton
Brighton Art Gallery
Bristol
Bristol Art Gallery
Burnley
Towneley Hall Art Gallery
Cambridge
Fitzwilliam Museum
Cardiff
National Museum of Wales
Glasgow
Glasgow Art Gallery
Kilmarnock
Dick Institute

Liverpool
Walker Art Gallery
London
British Museum
Guildhall Art Gallery
Hammersmith & Fulham Libraries
Leighton House
National Portrait Gallery
Royal Academy
Royal Institute of British Architects
Royal Society of Painters in Water-Colours
Tate Gallery
Victoria & Albert Museum
William Morris Gallery
Manchester
Manchester City Art Gallery
Newcastle-upon-Tyne
Laing Art Gallery
Oxford
Ashmolean Museum
Port Sunlight
Lady Lever Art Gallery
Preston
Harris Museum & Art Gallery

INDIA
Hyderabad
The Salar Jung Museum

ITALY
Florence
Uffizi Gallery
Rome
R. Accademia Romana di San Luca

THE NETHERLANDS
Amsterdam
Amsterdams Historisch Museum
Rijksmuseum
Arnhem
Rijksmuseum voor Volkskunde 'Het
Nederlands Openluchtmuseum'
Dordrecht
Dordrechts Museum
Groningen
Groningen Museum voor Stad en Lande
The Hague
Rijksmuseum Hendrik Willem Mesdag
Leeuwarden
Fries Museum
Soestdijk
Soestdijk Palace

NEW ZEALAND
Auckland
Auckland City Art Gallery

POLAND
Warsaw
National Museum

SOUTH AFRICA
Johannesburg
Johannesburg Art Gallery

SOVIET UNION
Leningrad
Museum of Pavlosk Palace
Moscow
Museum of Fine Arts (Pushkin Museum)

SPAIN
Madrid
Prado Museum

UNITED STATES OF AMERICA
Akron, Ohio
Akron Art Institute
Baltimore, Maryland
Walters Art Gallery
Boston, Massachusetts
Boston Museum of Fine Arts
Fogg Art Museum
Cincinnati, Ohio
Cincinnati Art Museum
Taft Museum
Hanover, New Hampshire
Dartmouth College
Madison, Wisconsin
Madison Art Center
Malibu, California
J. Paul Getty Museum
Milwaukee, Wisconsin
Milwaukee Art Center
Mineapolis, Minnesota
Mineapolis Institute of Art
Muskegon, Michigan
Hackley Art Gallery
New Haven, Connecticut
Yale University Art Gallery
New Orleans, Louisiana
New Orleans Museum of Art
New York
Corcoran Gallery of Art
Philadelphia, Pennsylvania
Philadelphia Museum of Art
Poughkeepsie, New York
Vassar College
Provo, Utah
Brigham Young University
Williamstown, Massachusetts
Sterling & Francine Clarke Art Institute
Zanesville, Ohio
Zanesville Art Center

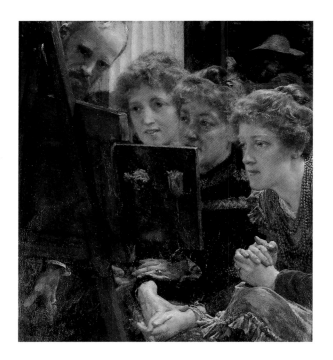

First published in 1989 by
PAVILION BOOKS LIMITED
196 Shaftesbury Avenue, London WC2H 8JL
in association with Michael Joseph Limited
27 Wrights Lane, London W8 5TZ

Produced, edited and designed by Russell Ash & Bernard Higton
Text copyright © Russell Ash 1989
Designed by Bernard Higton

A CIP catalogue record for this book is
available from the British Library

ISBN 1-85145-422-5

10 9 8 7 6 5 4 3 2 1

Printed and bound in Italy by L.E.G.O., Vicenza

PICTURE CREDITS

Half-title: *The Fountain* (1876): Hamburger Kunsthalle.
Frontispiece: *The Triumph of Titus* (1885): The Walters Art Gallery, Baltimore.
Self-portrait (1852): Fries Museum, Leeuwarden.
The Phyrric Dance: Guildhall Art Gallery, London, photo Bridgeman Art Library.
Architect's plan: The British Architectural Library, RIBA, London.
Egyptian motifs: Birmingham University Library.
A Sculptor's Model: Private collection, photo © Christie's.
Cleopatra (1875): Art Gallery of New South Wales, Sydney.
"Her Eyes are With Her Thoughts, and They Are Far Away":
Owen Edgar Gallery, photo © Sotheby's.
Bronze bust by Onslow Ford: Royal Academy.
Tailpiece: *A Family Group* (1896): Royal Academy, London.
Joseph, Overseer of Pharaoh's Granaries, *Antony and Cleopatra*, *The Frigidarium*
and *Under the Roof of Blue Ionian Weather* all photos © Sotheby's.
All colour plates reproduced with the permission of the collections indicated.